JOHN KIRBY

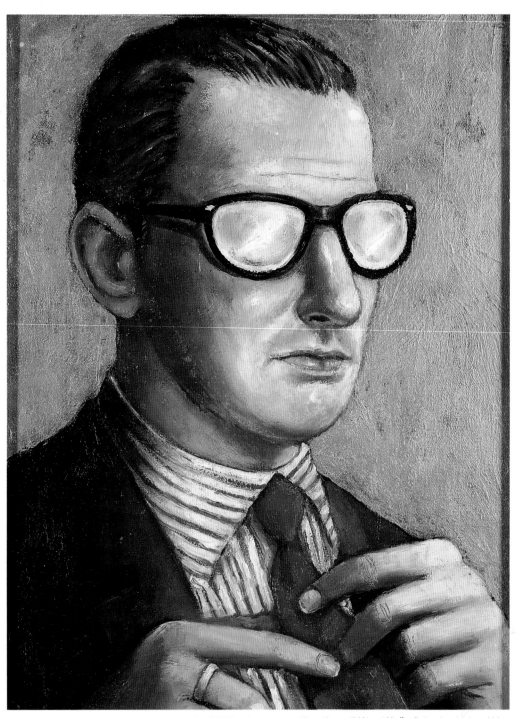

Economist Adjusting his Tie (1989), oil on canvas, 60 × 49 cm (23½ × 19¼"), Collection Nelson Woo

JOHN KIRBY

The COMPANY of STRANGERS

EDWARD LUCIE-SMITH

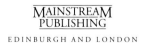
MAINSTREAM
PUBLISHING
EDINBURGH AND LONDON

First published in Great Britain in 1994 by
MAINSTREAM PUBLISHING COMPANY (EDINBURGH) LTD
7 Albany Street
Edinburgh EH1 3UG

ISBN 1 85158 625 3 (cloth)
ISBN 1 85158 626 1 (paper)

A catalogue record for this book is available from the British Library

The publisher gratefully acknowledges the assistance of Karen Demuth and
Matthew Flowers in the production of this book.

Typeset in Stempel Garamond by Litho Link Ltd, Welshpool, Powys, Wales
Printed in Singapore by Toppan

John Kirby is represented by Angela Flowers Gallery

Flowers East
199/205 Richmond Road
London E8 3NJ

Telephone 081 985 3333
Fax 081 985 0067

PREFACE

All art is ambiguous. Take an Old Master. Is it just a panel loaded with pigment, or a mystical allegory of Spring, or Botticelli's amorous representation of real-life beauties of the Italian Renaissance? The ambiguities of a painting like *Primavera* are lost in the wonder of its aesthetic achievement. That aesthetic is part of John Kirby's complex artistic heritage, as Edward Lucie-Smith makes brilliantly clear in these pages. Yet the book also shows how the elements in Kirby's work, paradoxically, fuse together to sustain ambiguity. This is an art which raises questions to which there are no answers.

There's even a strong element of paradox in the public reaction to Kirby's paintings. His dark themes deal with sexual ambiguity and with other unresolved issues that touch the most painful rites of human passage: such as the tug-of-war relationship with parents, the rejection of religious upbringing that can't be shed, the fear of a death that must be embraced, the questioning of personal identity, the conflict between love (sacred and profane) and its expression. The artist makes no attempt to hide these stark ambiguities. Rather, the paintings themselves are starkly painted; and yet they have an immediate and direct appeal.

The modern artistic influences on Kirby are explored by Lucie-Smith with consummate skill and scholarship. The artists concerned have this same perverse ability to arouse intense affection by painting images of alienation. Balthus, Hopper, Bacon and Freud take an uncompromising attitude towards their subjects. Described in language, their images often sound ugly and off-putting. But these four have all become oddly *popular* painters. The enthusiastic market for their work isn't one created by curatorial fashion, but reflects authentic and warm human reaction to what is often harsh and cruel imagery.

Those two adjectives don't apply to Kirby's work. But it is sombre; and he is equally unforgiving to his subjects – and himself. Lucie-Smith explores the autobiographical aspects of these paintings as deeply as possible, which isn't too deep, for Kirby is an intensely private man. Another ambiguity: the privacy co-exists with making public statements in paint about the most intimate concerns of the *persona*. But the troubled psychology strikes so many chords that these paintings hang in the owner's mind as they do on the domestic wall – as accessible, human and humane documents.

Much of this remarkable appeal, no doubt, reflects the way that Kirby paints his images. The deceptively simple, powerful composition; the careful use of light; the uncluttered arrangement of pictorial elements; the honest depiction of the human form and face; the presence of recognisable props and symbols; the controlled but expressive colour: all these are deployed to create a harmony that, again, conflicts with the agony of the themes.

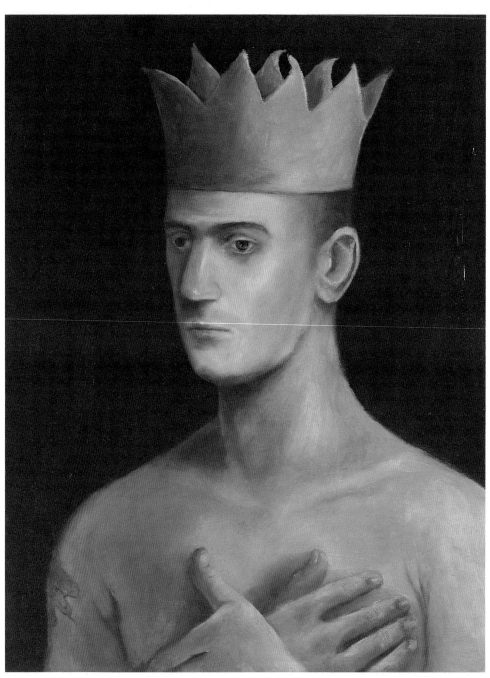

Man Wearing a Yellow Hat (1988), oil on board, 70.5 × 55.5 cm (27¾ × 22″), Private Collection

Religious paintings of the Renaissance, of course, often achieve precisely the same result.

Like those paintings, which have had so obvious and profound an impact on Kirby, his own work is notable, in an age of artistic confusion, for the clarity of what is actually depicted. The content can be exactly and simply described, with no need for guessing. As in the Renaissance, the artist uses symbols: but Kirby's are sparse and repetitive – the white rat, the bluebird tattoo, the paper crown, the masks, the flower, the concentration camp tower. They are not allegorical, however. They relate directly to the artist's personal vision.

Clarity ceases with the pictorial content. The meaning of the paintings, as with all art created at this high level, goes deep beneath the surface. The message, whatever its roots in the artist's psyche and intellect, and whatever its precise meaning, comes laden with angst. The pervasive theme of repression to which Lucie-Smith draws attention is partnered by evident feelings of guilt. Yet for all the guilt-laden atmosphere which Kirby can create so powerfully, these are not gloomy paintings: the darkness has its light side.

The emotional interplay helps explain why Kirby's work had so immediate an impact when first shown in public on the balcony of the International Contemporary Art Fair at Olympia in 1986. Kirby, then 37, had left St Martin's School of Art the year before. Lucie-Smith was among the very first to spot the strength of these paintings, and his advocacy played its part in the instant success of that balcony show. Moving on to the Royal College of Art, Kirby was quickly recognised as an important new painter, whose degree show again attracted keen buyers.

His first sell-out one-person show (1988) at Angela Flowers' cottage/gallery in Ireland launched a series of searching and successful exhibitions and changed Kirby's life in several respects, including domicile. Since starting to paint, he had always lived in England, save for a few months in New York and Paris. Now he has moved to a house near the Flowers cottage, and influences of Ireland can be traced in his latest work – though something of the Irish landscape and culture, with the pervasive sense of Catholicism, can be sensed in earlier paintings.

As Lucie-Smith points out, though, Kirby is not a painter of time, place or person: his work is figurative, but not representational – except to the extent that many paintings contain a strong element of family and self-portraiture. Sometimes the self-image is unmistakable; at other times, Kirby is painting the self rather than himself. While his background and nature are highly individual, the way he tackles the eternal difficulties of selfness has a directness that creates a strange empathy. An artist who explores the pain of being alone has the gift, through his work, of reaching out to others.

Lucie-Smith has explored, with great knowledge and wisdom, the artistic road that Kirby has travelled to these psychological ends. The author's exploration provides the peg for a masterly discussion of the nature and potential of end-century painting. To some, the mode which Kirby has chosen must seem old-fashioned. Others will feel that Kirby offers a convincing proof of a noble truth: that pigment, brush and canvas can still convey the innermost hopes and fears of the human heart with sensitivity, sensuality and the pervasive ambiguity which attends both art and existence.

Robert Heller
London, 1994

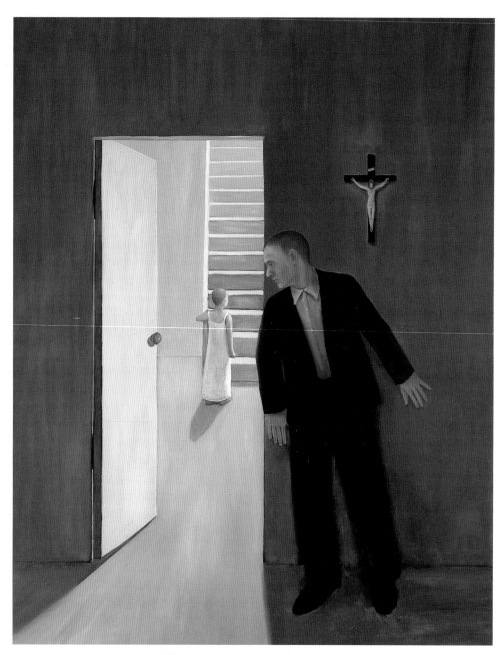

The Innocent (1991), oil on canvas, 213 × 168 cm (84 × 66″), Courtesy Angela Flowers Gallery

THE COMPANY OF STRANGERS

I

When one looks at paintings by John Kirby one is immediately aware that one is being offered admission to a very strange world. Let me enumerate some of the things one might see in this world, for certain themes recur obsessively. There are, for example, figures knee-deep or even neck-deep in the sea. There are figures standing on cliff-edges, overlooking that same sea. There are figures eavesdropping, aware of some activity in an adjoining room. There are also figures entirely alone, shut in some dreary cell-like space, but sometimes accompanied by a large rat, or a bull-terrier-like dog. There are men dancing rather formally together, as if performing an old-fashioned waltz or foxtrot. There are men wearing dresses, and men wearing bridal veils (which may also be the veils worn by little girls at their first communion). There are men and boys dressed up as angels, sporting property wings and sometimes a wire halo.

In these pictures one learns to look for characteristic props, and also typical gestures. Among the props are blindfolds, masks, playing-cards, rosaries, and the kind of paper crown found in a Christmas cracker. This last is usually worn by a youth or young boy. There are business suits, outfits with prison stripes and the occasional pair of dark glasses. Many of the male figures sport a small tattoo of a bluebird on their left shoulder. They cover their eyes, or place a finger on their lips to enjoin silence, or put their palms together in a gesture of prayer. Sometimes a forehead will be marked with a small cross, apparently carved into it; or else a hand will show the mark of the stigmata.

What explanation can be offered for this disturbing pictorial universe? Does it have any relationship to the accepted world of contemporary art? In order to answer these questions, one has to step quite a long way back, and take a broad historical view. Kirby presents a determinedly negative reaction to some of the chief artistic currents of our time.

II

Since the Renaissance, painting (specifically the use of pigments on canvas) has been one of the major forms of expression in Western art – though there have, of course, been plenty of other cultures where it has not been primary. Following the rise of the Modern Movement, however, it has been struggling

to maintain its central place. It has been challenged on several fronts. Environmental and site-specific work has become increasingly fashionable, especially in the last two decades. There has also been much interest in a wide range of other activities, all of which usually go under the label 'sculpture', even though the end product tends to have little to do with traditional sculptural norms. Photography, now possessed of a wide range of technical possibilities, has been seen as a more telling way of creating images than the application of paint to canvas, and one more suited to the mechanical civilisation we now possess. Thanks to these developments, many influential critics and curators, particularly in the United States, have been predicting the demise of painting as a significant means of communication. This represents a great shift in attitude. Up to perhaps the middle of this century, anyone who wished to practise as an artist had to think of painting as a first choice. Now the decision is by no means so clear-cut.

In addition to this, there is confusion amongst painters themselves. The tide of abstraction, which reached successive high points with the Russian Constructivists, the American Abstract Expressionists of the 1940s and 1950s, and the Minimalists of the late 1960s and early 1970s, is now again starting to recede. There are still, nevertheless, plenty of artists and theoreticians around who think of paint on canvas as being primarily a way of articulating a surface. That is, they essentially believe that the main subject of art is art itself, and that paintings should be designed to deliver a purely aesthetic experience. The work of highly respected artists such as Robert Ryman and Agnes Martin belongs to this category.

There is another group which believes that the business of the painter is to transcend quotidian reality. What he leaves behind him on the canvas should therefore be a series of mysterious signs which map a voyage into an immaterial world. This is one way of interpreting the work of Cy Twombly.

There is yet a third category of contemporary artist who sees the act of painting as being essentially a triangular dialogue between the person making the artwork, what is represented, and established conventions of representation. This description can be applied to artists otherwise as different from one another as Roy Lichtenstein and Chuck Close.

John Kirby belongs to none of these groups. The paintings he makes are full of meanings which have nothing to do with aesthetic theory. Even the way in which he covers his surfaces makes it clear that it is the image itself, not the painting-as-independent-object, which plays a primary role in his work. He is not entirely alone in this. Parallels can be drawn between his work and that of other leading twentieth-century artists. Two who immediately come to mind are René Magritte and Francis Bacon. What these have in common with Kirby is their insistence that painted images are still an efficient way of conveying extra-artistic meanings: that painting still has something vital to say about the nature of the world outside the studio.

Seated Man (1986), oil on canvas, 122 × 91.5 cm (48 × 36″), Collection John Hansard Gallery,
University of Southampton

III

The great artists of the pre-Modern tradition would have found my insistence on this point strange. For them it was self-evident that the main reason for making a painting was that it had something to say about the nature of the world. The painter was integrated with a whole social system, and what he did was done as the direct fulfilment of social and religious needs. The relationship could be extremely direct, as, for example, when Titian painted his *Assuntà* for the church of the Frari in Venice, or when Van Dyck produced portraits of Charles I and Henrietta Maria. Sometimes it was seemingly more distanced. We know that many of the leading Dutch painters of the seventeenth century painted speculatively for the market, just as artists do today. What they produced, however, held up a mirror to the tastes and assumptions of Dutch bourgeois society.

During the eighteenth century there was a further development in the art market, as artists became increasingly dependent on reproductive engravings for part of their income. This threw increased emphasis on the value of the image, rather than in any way diminishing its importance, since the image, rather than qualities of facture or surface, was essentially what the engraver transmitted to the public. Among the artists who profited in this way were William Hogarth in England, with *The Rake's Progress* and other satirical and moralising prints (whose nuances were faithfully reproduced because Hogarth did the engraving himself), and Jean-Baptiste-Siméon Chardin in France. Whereas Chardin's still-lifes were addressed solely to a market of connoisseurs, his domestic scenes appealed to a much wider public.

The widespread diffusion of prints of this sort represents a middle stage in a process of democratisation which had been affecting the visual arts in Europe for two centuries, ever since the introduction of printing. The first step was the appearance of large numbers of original prints, and especially large-format woodcuts, issued as single sheets by the great masters of the German Renaissance, chief among them Albrecht Dürer. These prints put works of art into the hands of a new class – townspeople in a modest way of business and even the richer members of the peasantry. It is on record, for example, that Dürer's prints were sold at fairs, along with many other commodities, most of them the simple necessities of everyday life.

The third part of the process of democratisation is more recent. It is linked to the development of the illustrated art book in our own time. This volume is itself part of the process. Indeed, some experts would say that both it, and many other books like it, represent a final stage, since they, in their turn, are due to be replaced by new forms of electronic technology.

One mystery here, nevertheless, is why, despite ever more efficient means of diffusion, the importance of the painted image, as source and prime original, has recently tended to diminish. One can continue to look for an explanation in art history, but only by taking a slightly different approach.

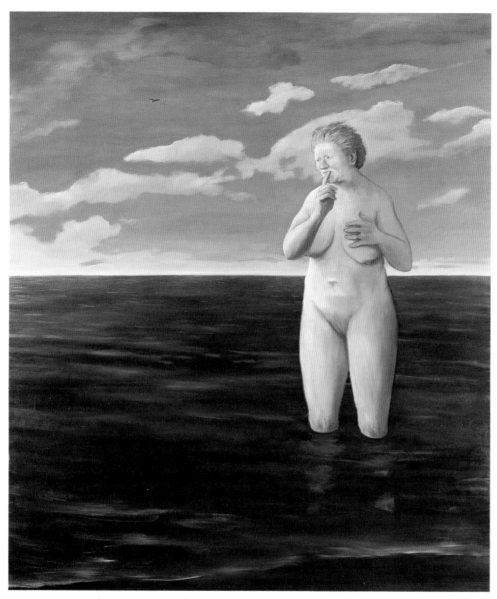

No Shame (1992), oil on canvas, 214 × 183 cm (84 × 72″), Courtesy Angela Flowers Gallery

IV

There were two important developments in Western art during the period from *c.*1500 to the mid-nineteenth century which seem to fall outside the simple pattern I have already outlined. The first was the growth of a cult of personality, soon deepened and extended to become a cult of genius. The second was a new moralism in art, which eventually acquired political overtones.

The earliest focus for the cult of genius was Michelangelo. Many of our basic notions about genius and its mode of operation in all fields of artistic and scientific endeavour were first formulated in two biographies written in Michelangelo's own lifetime, by men who had known him personally. One is by Giorgio Vasari, the other by the lesser-known Ascanio Condivi. Though both authors stress Michelangelo's piety and humility before God, underlying what they write about him is the idea of the god-like man, able to challenge divine creativity, and thus transcend the bounds ordinarily set for human beings.

This was an infinitely seductive idea. Artists soon, rather than waiting for genius to be attributed to them by others, started to claim it for themselves. The seventeenth-century Italian painter Salvator Rosa does so, for example, in an etching dedicated to his own fame – *The Genius of Salvator Rosa*. This bears a Latin inscription which reads, in translation: 'Sincere, free, fiery painter and equable despiser of wealth and death, this is my genius. Salvator Rosa.'

Mingled with this claim, as Rosa formulates it, are ideas taken from ancient Stoicism. It is therefore not surprising to find the following description of him in a near-contemporary source: 'His manner of living was that of a philosopher, which he affected to show in his paintings, giving them a moral signification.'[1] What this implies is that Rosa was in fact a role-player, and we can confirm this from other details of his life. We know, for example, that he wrote plays and probably performed in them; and that he liked people to think that he had lived a dramatic life, mingling with Neapolitan bandits and other outcasts.

With Rosa, in fact, we encounter the beginnings of a shift of focus. Attention is transferred from the artist's works as independent, self-sufficient statements, to paintings and sculptures as expressions of a personality, which is now the most important and central artifact, with individual works as mere guarantees of its existence. The Romantic Movement which put the emphasis on the artist as hero, forever at odds with the rest of society, carried this a stage further. In our own time, the balance has shifted so completely that artworks are often treated simply as relics, evidence of the passage through the world of some secular saint. This is the case, for example, with much of the *oeuvre* of Joseph Beuys. In these circumstances artworks lose their power as images, and are valued, instead, for the associations which seem to cling to them.

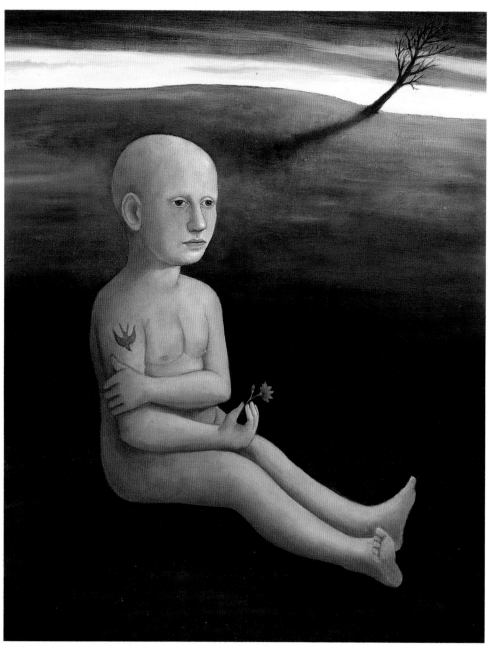

A Boy with Blue Flower (1993), oil on board, 91.5 × 61 cm (36 × 24″), Courtesy Angela Flowers Gallery

V

The 'moral signification' which Rosa attached to his work is also important, though here he was somewhat in advance of his time. The idea that art must essentially be a vehicle for moral and social precepts did not fully establish itself until the mid-eighteenth century. It did so in the hands of Denis Diderot. Diderot's reports on successive French Salons – official exhibitions sponsored by the Académie Royale des Beaux Arts – circulated throughout Europe, as part of the *Correspondance littéraire* edited by Baron Friedrich Melchior Grimm. These lengthy essays established their author as the first modern art critic.

Diderot was a partisan, and his partisanship was motivated by his dislike of the government of Louis XV. He supported the work of Jean-Baptiste Greuze and execrated that of François Boucher, *premier peintre du roi* and a brilliant exponent of the hedonistic Rococo style preferred by the court and especially relished by the king's mistress, Mme de Pompadour.

What Diderot found in Greuze's sentimental genre scenes (quite closely related to those of Chardin) were qualities he thought the opposite of those of Boucher:

> To begin with, his genre is to my liking, for Greuze is a painter of morals. What then! Has not the brush been devoted to lewdness and vice long enough? Should we not rejoice that he is competing with dramatic poetry in order to move us, instruct us and exhort us to virtue? Courage, my friend Greuze, go ahead and moralise with your paintbrush, and always continue in this manner! When you are about to depart from this life there will not be a single painting that you may not recall with pleasure.[2]

Like the scenes Hogarth devised for his *Rake's Progress*, Greuze's genre paintings are essentially dramatic tableaux – narratives interrupted at their most significant moment. In one of the best known, *The Village Bride*, Greuze chooses the instant when the father of the bride hands over the dowry to his son-in-law. This was significant in two respects: it emphasises that marriage, in a bourgeois setting, is always involved with the idea of property; and it allows Greuze to indicate, though indirectly, that the marriage ceremony is Protestant not Catholic – a sly gesture of defiance to the *ancien régime*. Seeing the painting, Diderot reported with enthusiasm: 'The composition seems very beautiful to me; it tells the story the way it must have happened. There are twelve persons; everyone is placed and acts as he should.'[3]

VI

What Greuze did in a sentimental key, while also paying due deference to the power of money in a bourgeois society, his lineal successor, Jacques-Louis David, presented in a far more powerful and heroic fashion. In his most ambitious and complex compositions David, too, is primarily a moralist – a preacher of the revolutionary, then the imperial virtues. There is great interest in the story of the Emperor Napoleon's

visit to David's studio, amidst the feverish hurry of the Hundred Days, in order to inspect David's *Leonidas at Thermopylae:*

> As soon as he came in, he said that he knew the painting without having seen it, and had heard it much praised. Then, after looking at it, he, who had always supposed that it would show the Persian attack and the vigorous resistance of the Spartans, gave vent to his astonishment at the scene David had chosen. The artist, still full of his earliest thoughts on the matter, explained in detail the way in which he had conceived the work. Napoleon, however, could not be reconciled to David's idea, for the latter, instead of painting the battle itself, had chosen the moment that preceded it.
>
> Nevertheless the Emperor expressed his satisfaction and said, as he departed: 'David, continue to make France illustrious through your work. My hope is that copies of this painting will soon be hanging in our military schools. They will remind the students of the virtues of their calling.'[4]

In a sense it may seem astonishing to quote an anecdote about David – and furthermore David in his most official role – in an essay about a late twentieth-century painter. David, after all, was the founder of a stringent academic method, and it was against the rigidity of his system that the Impressionists, followed by the founders of Modernism, rebelled. Yet it is also true to say that David has been a persistent ghost, whose presence is more, rather than less, felt in the closing decade of the twentieth century.

It is not his method which is responsible for this, but his biography. David was the first European artist to be fully involved in the politics of his time, as a protagonist, not a mere spectator. Successive major works – *The Oath of the Horatii, Marat assassiné,* *Le Sacre* – were direct interventions in the course of French history. The nature of that history was such that each of these paintings encapsulates a moral as well as a political viewpoint.

It has been a noticeable, if intermittent, feature of twentieth-century Modernism that artists have wanted to assume political roles. The Futurists in Italy were for a moment the rivals of Mussolini's Fascists, and eventually became their allies. The Russian Constructivists, though not originally Communist, enthusiastically identified themselves with the revolution of October 1917, and for a time produced art which tried to reconcile Modernist abstraction with the propaganda needs of the Party. In Mexico, the leading muralists – Rivera, Orozco and Siqueiros – tried to produce art which, while retaining at least traces of Modernism, would speak for the whole mass of the Mexican people. In the 1920s and 1930s, the Surrealist movement, led by André Breton, conducted a long and finally unsuccessful flirtation with Russian Communism. In 1937, Picasso painted his mural, *Guernica,* as a gesture of support for the Spanish Republican government, then at war with the rebel forces of General Franco. The link between *Guernica* and David's history paintings has often been noted by critics. The situation was well described by Tim Hilton in his excellent concise study of Picasso: 'It is not suggested that David is there, in the picture, as a visible "influence". What is suggested is that Picasso's neo-classicism, long established in his own art, now becomes grandiosed [*sic*] into a stately display of conflict which has a strong undertow of David's tradition.'[5]

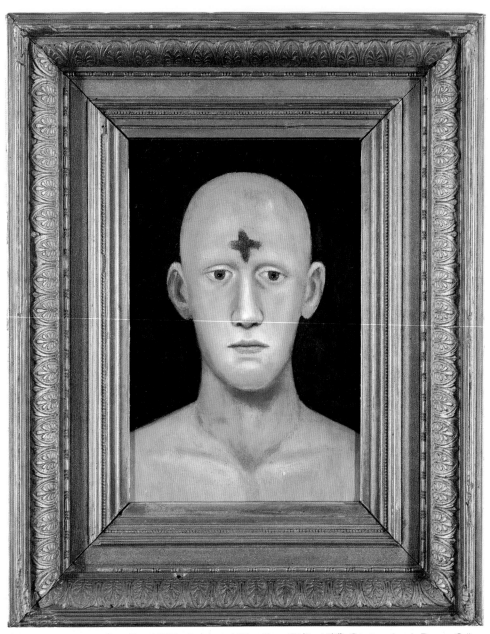

Sign of the Cross (1993), oil on board, 54 × 42 cm (21¼ × 16½″), Courtesy Angela Flowers Gallery

THE COMPANY OF STRANGERS

Effectively, the Davidian heritage placed Modernist artists in a dilemma. They wanted to see themselves as being, like him, effective protagonists on the political stage. They also saw themselves as playing the role of philosopher, *à la* Salvator Rosa. At the same time, they wished to preserve the distance between themselves and the art of the pre-Modern period which was, for them, the mark of their own specialness – in fact, of their claim to 'genius'.

VII

The solution, increasingly, has been to return to an art of public statement, but using means of expression which are recognisably new. Contemporary art, during the past two decades, has gradually abandoned the 'art for art's sake' position adopted by the Minimalists, and has returned to the creation of work with recognisable political and social content. Certain themes have been especially popular – dangers to the environment, gender differences, the disadvantages suffered by racial and sexual minorities. The preferred means of expression have often been environmental art and performance work of various kinds, live and on video. That is, the participants in this new movement, while adopting a public position closely akin to that once occupied by David, have nevertheless been careful to stress the gap between their own activity and the forms of the past.

Perhaps, simply because of this, more profound links with the past – a renewal of certain bonds – have gone largely unnoticed. For example, the new political art I have been describing, though apparently the product of farouche, wayward individuals who are enforcing a claim to operate beyond the normal bounds, is in fact expressing a consensus – the opinions of a liberal élite. This liberal élite makes up the large majority of the museum and gallery-going public, and it is museums and publicly funded galleries which form the main theatre for this kind of avant-garde activity. These massive environmental works – Judy Chicago's feminist *The Dinner Party* (1974) is a good example – are, in fact, official statements of the same sort as David's heroic compositions, and are displayed in very much the same fashion: as public entertainments, mingled with a strong element of moral and social instruction. Where does this leave artists like John Kirby, who insist on making recognisable images, using the traditional medium of paint on canvas? The answer is summed up in a single word: 'outside'. Outside the main parameters of the cultural establishment of their time.

VIII

As I say this, I can immediately hear voices raised in protest. Isn't what I have just said a reckless exaggeration? Kirby, who is now in his forties, has had what seems like, for a British painter of his generation, a reasonably conventional career. He studied at two prestigious London art schools, St Martin's and the Royal College. He has held seven one-person exhibitions, among them one in Ireland

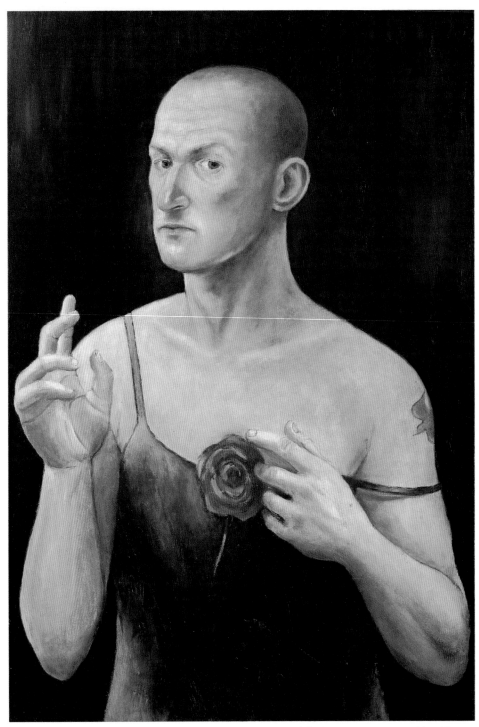

Self Portrait (1987), oil on board, 109 × 79 cm (43 × 31″), Collection Matthew and Huei Flowers

and one in the United States. His work has featured in more than a score of mixed shows. In fact, the pattern is very much what one would expect of a successful artist in mid-career.

It is only as one starts to look more closely that discrepancies from the usual pattern begin to emerge. For example, this is someone who started very late. He was already well over thirty when he reached St Martin's. Before that he had held a wide variety of jobs, working as a shipping clerk, as a salesman in a Catholic book-shop, as assistant to the director at Mother Theresa's Boys Town in Calcutta, as a probation officer and even as Third Assistant Stage Doorman at Covent Garden Opera.

None of his one-person exhibitions has taken place in a museum or public gallery context. The mixed exhibitions have tended to be equally unofficial, the sole exception being the touring show 'The Self Portrait: a Modern View', organised by the publicly funded Artsite Gallery in Bath, and seen in several British museums during more than a year's tour. In this, Kirby was represented by a single picture – a self-portrait showing the artist in female dress. His museum representation is also extremely sparse – just one painting in the Ferens Art Gallery in Hull, presented to it by the Contemporary Art Society, and one in the John Hansard Gallery, University of Southampton.

Yet this is also an artist who is in commercial terms successful – his gallery finds it difficult to keep his work in stock, and it is bought by a wide range of British and American collectors, among them the celebrated actress and singer, Madonna.

In a sense, therefore, this book is the first exposure of what has hitherto been an extremely private reputation, one which has flourished independently of the official mechanisms of the world of contemporary art. This is not itself, of course, a guarantee of quality and interest. Who is to say that the experts and pundits who have ignored his work up till now are all of them wrong? (It must also be noted that the bibliography of writings about John Kirby's work is remarkably short.)

IX

John Kirby is not the only artist now at work in Britain whose career shows some of the characteristics described above. If one looks, for example, at the career-pattern of Lucian Freud, now widely hailed, since the recent death of Francis Bacon, as Britain's leading figurative painter, one encounters some striking similarities. Freud's artistic education began earlier than that of Kirby, but was nevertheless sketchy and unorthodox. His most important period of study was during the Second World War, at the East Anglian School of Drawing and Painting, a small and extremely informal institution run by the self-taught painter Cedric Morris and his partner Lett Haines. He first exhibited in a commercial gallery in 1944 and achieved his first official recognition at the Festival of Britain, followed by an invitation to exhibit at the British Pavilion at the Venice Biennale of 1954. His two co-exhibitors in Venice were Ben Nicholson and Francis Bacon.

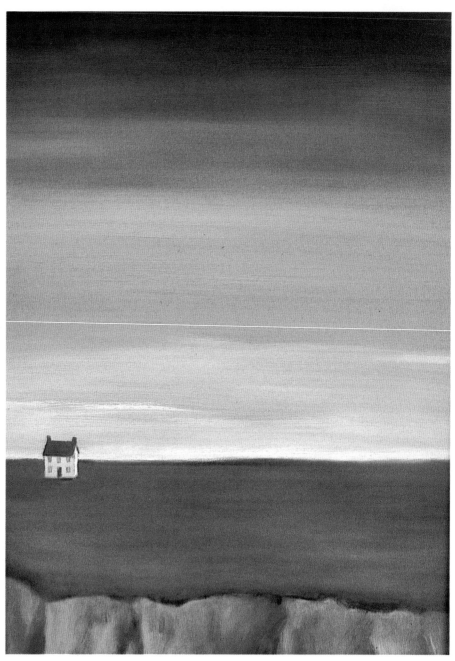

The House of Special Purpose (1991), oil on canvas, 55 × 40 cm (22 × 16″),
Collection Mr and Mrs Carmichael

After this, however, there was a long hiatus. Freud's first major retrospective, organised by the Arts Council of Great Britain, did not take place until 1974; his international fame had to wait until the 1987 retrospective organised by the British Council at the Hirshhorn Museum in Washington DC.

What was Freud doing during the twenty years between 1954 and 1974, which is essentially the period during which he stabilised his personality as an artist and established his mature style, very different from the tight neo-Romantic manner of the 1940s and early 1950s? The answer is that he lived and worked on the fringes of an aristocratic world with strong links to the British political and financial establishment, but somewhat distanced from the visual arts bureaucracy which was busy promoting the careers of near-contemporaries such as Henry Moore. One of his steady sources of patronage, for example, was the Devonshire family. As a result, Freud is better represented at Chatsworth than in any British public collection.

Freud's method and range of subject matter were both suited to the essential privacy of his approach. What he painted was, in the most literal sense, precisely what was in front of him: figures in the studio. There is, however, a twist to this situation: the spectator may surmise that with many of his subjects the artist has close personal, often erotic, relationships.

The years of Freud's public fame have not changed the nature of his work. All that has happened is the admission, into a situation originally known to only a very few, of a voyeuristic mass public. One inevitable result has been intense curiosity about the circumstances of Freud's life. The artist has resisted this. One may guess, for example, that many of his extraordinarily intimate female nudes and female portraits (the dividing line between the two is not always exact) are likenesses of his lovers, but titles such as *Naked Girl Asleep* deliberately withhold information.

As Freud's reputation has grown, these enigmatic images have been the subject of much journalistic speculation, on the borderline between art criticism and gossip. Freud himself has seemed to accept this on one level, while refusing to co-operate with it on another. His basic contention has been that his main purpose in making pictures has been to recreate on canvas, as fully as possible, the life he sees before him.

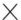

One can make comparisons between Kirby's career, and the type of patronage he has attracted, and that of Freud, but it is also clear that there is a very important difference. Freud proclaims, almost defiantly, his complete dependence on the presence of the model. Kirby paints things he has imagined, fused with things he has remembered. Freud's revelations about his own life and psychology appear to be inadvertent, a by-product of the process of recreation mentioned above. Kirby's disclosures, if frequently coded and ambiguous, are deliberate: the main subject of his art.

It is worth taking a few images almost at random, to see what they consist of. *Lost*

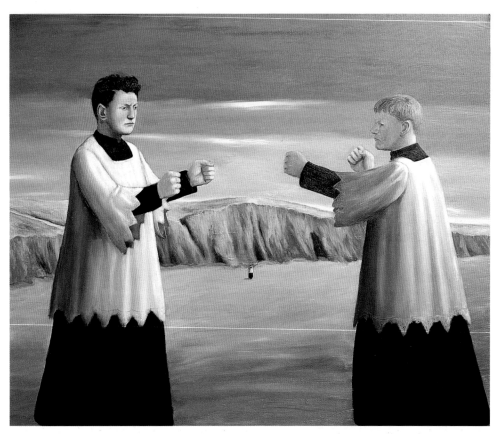

Lost Boys (1991), oil on canvas, 152 × 183 cm (60 × 72″), Courtesy Angela Flowers Gallery

Boys (1991) shows two youths dressed as Catholic altar-boys, about to fight one another. They are standing in the midst of a vast, dreamlike landscape; in the far distance one can see a third, minute figure, similarly dressed. Kirby says the two youths are his two older brothers, who were always fighting, and that the distant spectator is himself. 'Did you mind it when they fought?' I once asked him.

'No – I thought it was interesting. And of course when they were fighting they were too busy to beat me up.'

Another painting, *Pierrot and Columbine* (1991), shows a masked couple.

The man, seated, is playing a small guitar. The woman stands and puts her hand possessively around her partner's neck. Kirby says they represent his parents. 'My parents are dead now and I think about their relationship often. I'm not sure what it was all about. Anyone who knew my mother would recognise her immediately from her hand, the one which gestures away to the right. The other one isn't so good.' The comment shows an insistence on a certain kind of realism, but only within strict limits. One detail may indeed conform closely to something the artist has observed, but we are not expected to think

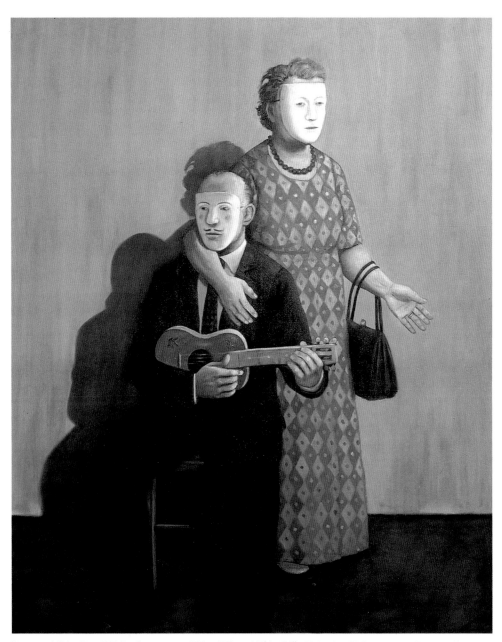

Pierrot and Columbine (1991), oil on canvas, 176 × 137 cm (69¼ × 54″), Collection TI Group

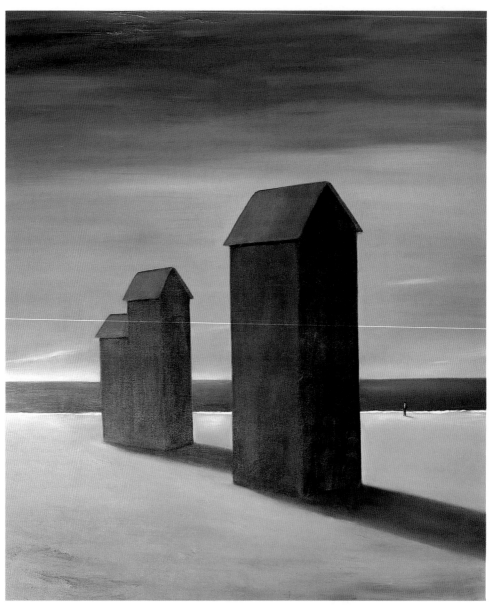

On the Beach (1991), oil on canvas, 183 × 159 cm (72 × 62½"), Private Collection

that the couple he shows us ever looked or behaved precisely like this. They are emblems of themselves, existing in some non-specific, non-temporal realm.

XI

A third painting, close in date to the two others just cited, shows three very tall sentry-box-like huts standing on a level beach – they look like coffins standing on end. Once again a tiny Kirby-figure is visible in the middle distance, standing on the edge of the sea. The artist says that the motif was suggested by fishing-net huts in Hastings, but that he greatly exaggerated the size of the constructions when he came to paint the picture.

I wondered for a long time what this picture reminded me of, but only realised recently that what it recalled were the various versions of Magritte's *The Lost Jockey*, where a miniature horseman gallops between gigantic skittles or balusters. It so happens that the image occupies a particularly significant place in Magritte's career. The first version, painted in 1926, was one of the artist's first surrealist images, and he attached a special importance to it. He told a friend that it was 'conceived with no aesthetic intention, with the sole aim of *responding* to a mysterious feeling, a "causeless" anguish, a sort of "call to order".'[6] It is fair to say that Kirby's image distils the same feeling, using much the same means – contrasts in scale to create a feeling of psychological displacement, a sense of emptiness with an underlying

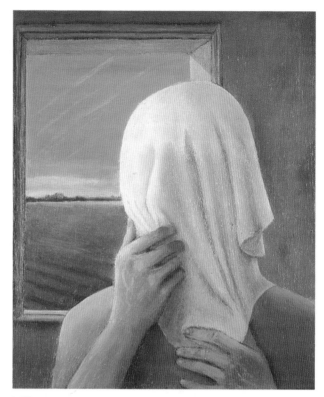

Self Portrait in Homage to René Magritte (1993), oil on board, 22 × 18 cm (8½ × 7″), Collection Jonathan Naggar

current of menace.

Finding one similarity to Magritte encouraged me to look for others, and these were not slow to appear. Kirby, for example, makes use of a motif which is particularly important to Magritte – that of a head completely shrouded in a white cloth. This appears most memorably in *Les amants* of 1928, where two swathed lovers kiss. The resemblance to Kirby's *Virgin of Sorrows* (1991) is very striking. And, since so many of Kirby's images deal in one way or another with dysfunctional family relationships, one is reminded that some commentators think that Magritte got this one from a particularly tragic incident in his own family history – the suicide by drowning of

Virgin of Sorrows (1991), oil on canvas, 244 × 183 cm (96 × 72″), Courtesy Angela Flowers Gallery

his mother. The body was discovered with its clothing drawn up over its head.

The really striking link between Kirby's work and that of Magritte is, however, a technical one. The superb Magritte retrospective of 1992–3, seen in London, New York, Houston and Chicago, laid to rest one persistent criticism – that Magritte is technically stiff and uninteresting. The neutral style which Magritte adopted was exactly suited to his purpose. His images were not true representations but signs, and he adopted a sophisticated version of traditional sign-painting technique to make this point and give his inventions their full force.

Kirby's work often has a somewhat similar impersonality of surface, joined with a sign-painter's tendency to generalise. Some of this can perhaps be attributed to the late start he made as an artist. Yet it is also true to say that the apparent stiffness of his paintings reinforces their impact. What is shown is so bluntly presented that the viewer has no chance of avoiding its implications.

XII

Does this mean that I think Kirby is a surrealist artist – a belated successor to Magritte? The brief and blunt answer to this must be 'no'. Magritte is essentially an artist of deliberately irra-

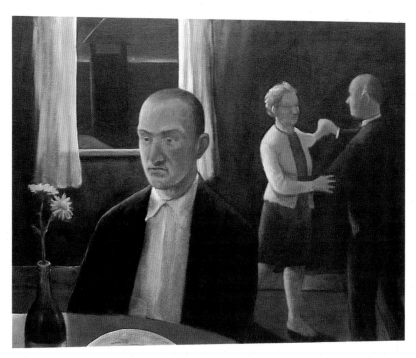

Nature Morte (1987), oil on canvas, 91.5 × 122 cm (36 × 48″), Collection Angela Flowers

tional juxtapositions. In another of his 'shrouded head' paintings, *L'Histoire centrale* (1928), the single female figure is accompanied by two objects – a trombone and a small suitcase or attaché case. There is no special reason for this conjunction – it is deliberately arbitrary. Magritte explicitly disapproved of attempts to provide rational or quasi-rational interpretations. 'People who look for symbolic meanings,' he said, 'fail to grasp the inherent poetry and mystery of the image. No doubt they sense this mystery, but they wish to get rid of it. They are afraid. By asking "what does it mean?" they express a wish that everything be understandable.'[7]

I doubt if this is John Kirby's point of view. Unlike Magritte's paintings, many of his are quite clearly intended to be symbolic. The personages and objects shown are all related to a central, fixed core of meaning; there is nothing aleatory about them, and he invites understanding from the viewer, but not the kind of complicity which Magritte seems to aim for. The 'I' of the artist and the 'I', or ego, of the spectator, do not intermingle, as they do in true surrealist works.

In addition to this, a number of Kirby's paintings are narratives of a fairly traditional type. When we are shown a scene with three figures – a mature couple dancing, and a young man seated at a table who deliberately ignores them (*Nature Morte*, 1987) – we are fairly obviously being invited to step into a story which has a beginning, a middle and an end; a story different from, but comparable to, the one which is told in Greuze's *The Village Bride.*

On the other hand, it is equally clear that there is a great gap between Kirby and Greuze because one is a post-Freudian and the other a pre-Freudian artist. The Surrealists, who were responsible for importing Freud's doctrines into art, changed the nature of pictorial imagery forever, and Kirby is just one of very many twentieth-century figurative artists who are for this reason in their debt.

XIII

If Kirby is neither truly like Lucian Freud nor like Magritte, which other artists does he resemble? The answer comes swiftly to mind. He belongs to a category which is well populated in the second half of the twentieth century: he is the painter as candid autobiographer. Yet here it is necessary to note that the artists of our time have entered this classification for both positive and negative reasons. The negative cause is the loss of the great narrative themes, religious and secular, which preoccupied the majority of artists in the past. Neither religion nor mythology now serves as common ground between the artist and his or her audience. Painters, like other artists, can either embrace a spectrum of political and social causes (with all the risks of ephemerality this entails). Or they can confine themselves to pure aesthetics. Or they can try to use the particulars of their own lives as the basis for a universal language of feeling.

In the United States this was attempted by the Abstract Expressionists of the 1940s and 1950s. What they produced was largely, though not completely, non-figurative. Mark Rothko, whose mature paint-

ings contain no hint of figuration, once said that what he wanted to do was make people weep. He aimed at a kind of direct communion of souls.

In Europe, there have been artists, usually stylistically isolated, who have aimed to do the same thing by inventing their own range of figurative imagery as a substitute for the universal language of the past. Their motto might have been taken from W.H. Auden:

> Private faces in public places
> Are wiser and nicer
> Than public faces in private places.

Among the names which come to mind are those of Balthus and Francis Bacon.

It is not an accident, I think, that the major theme which both of these share with Kirby is sexuality, since sex remains one of the few great universals of our society. However varied its manifestations, it is an urge which almost every spectator can relate to personal experience. At the same time, dealing with sex forces the artist to be specific, while specificity is what abstract art abandons.

XIV

The writer Bill Hopkins, one of Kirby's earliest collectors and admirers, and a keen analyst of the position of the 'outsider' in modern society, sees Kirby as the natural successor of Bacon. For Hopkins, both are 'outsider' artists, but with this difference – Bacon was a participant in what he painted, while Kirby remains an observer.

There are certainly suggestive resemblances between the two painters, as well as certain biographical and psychological links. Both have concerned themselves with the homoerotic and with questions of gender. Bacon was an even later starter than Kirby, received even less formal training and took a longer time to find his vocation. Like Kirby's, many of Bacon's most powerful works are self-evidently autobiographical. Indeed, they often go further than Kirby's in a confessional mode. Examples are the three triptychs which Bacon painted in 1972–74 to commemorate the suicide of his lover, George Dyer.

In his smaller paintings, Kirby takes up ideas which seem to be borrowed directly from Bacon. His small paintings of heads, like Bacon's, are often either self-portraits or generic images based on his own appearance. One can also spot favourite Bacon themes elsewhere in his work, such as the image of the conventionally suited businessman. Both artists use the concept of an interior as a kind of enclosing box. A room is something which contains an emotion, puts it under pressure, as it also contains some kind of event.

Yet there are also striking differences. Bill Hopkins, despite his insistence on linking the two artists, points out that Bacon identifies himself with the protagonists he creates, becomes one with them, while Kirby, on the contrary, 'manifests them, and then stays watching'.[8]

A striking characteristic of Bacon's figures is their physical fluidity. The artist seems intent on catching them in a state of transition – moving physically from one position to another and mentally from one

state of being to another. These transitions take place in an atmosphere of hysteria. The resemblance between Bacon's work and that of the melodramatic Anglo-Swiss painter Henry Fuseli, a leading figure in the late-eighteenth-century *Sturm und Drang*, has been pointed out. At his most extreme – for example, in his best-remembered painting, *The Nightmare* (1781) – Fuseli stresses and deforms the human body very much as Bacon does. There are other, perhaps coincidental, resemblances as well. The greyish tonality of Fuseli's work, and the starved texture of his surfaces, are similar to those of Bacon's early paintings. There is nothing much like this in Kirby – his figures are solidly planted, sometimes stolid, and carefully built up.

Another contrast between Bacon and Kirby is something very simple, and of greater significance in the long-run than Bacon's dependence on some of the devices of early Romantic art. This is Bacon's close relationship to photography. The link is of two kinds – the use Bacon makes of specific images, borrowed from favourite sources such as Eadweard Muybridge's *The Human Figure in Motion* (1887) or the 'Odessa Steps' sequence of Sergei Eisenstein's film *Battleship Potemkin* (1925). There is also the way in which Bacon's whole convention for showing figures in movement depends on photographic blurring; on what happens when the person or object being photographed is moving too rapidly to be frozen in place by the chosen shutter speed. Kirby's work is remarkably free of any trace of photographic influence, and this is one of the things which makes him an exception in the ranks of twentieth-century figurative painters.

XV

To me, Kirby seems much closer to Balthus than to Bacon, despite the wide difference in their backgrounds. Balthus is a complete cosmopolitan – born of Polish and Jewish stock, originally a German citizen, brought up largely in Switzerland, and finally recognised as a major French artist. Despite the fact that both his father and his maternal uncle were painters, Balthus is almost entirely self-taught. Throughout his career, he has remained an unclassifiable maverick. For instance, though his first one-person show, which took place in Paris in April 1934, was held at a private gallery closely associated with the Surrealists, he was never a member of the Surrealist group led by André Breton.

What shocked some of those who visited the show was the forthright eroticism of Balthus's subject matter. One painting, *The Guitar Lesson*, had to be exhibited in a back room, accessible only to a few. It is an expression of a theme which was to be constant in Balthus's work – his obsession with the sexuality of very young girls. In *The Guitar Lesson* a pre-pubescent girl is bent backwards over the lap of a mature female. Her skirts are raised well above her waist and the older woman touches her vagina. She, in turn, raises a hand to the older woman's breast, exposed by her open blouse. As Sabine Rewald points out, in her introduction to the catalogue of the Balthus retrospective held at the Metropolitan Museum in New York in 1984, the source for the composition is the famous *Avignon Pietà* in the Louvre.

One reason why Kirby resembles

Balthus is that he also often combines religious and sexual imagery. Two paintings which come to mind in this connection are *Prayers for a Dead Rat* (1990) and *The Dead* (1993). The first shows a male figure, nude but for a bridal veil, standing with hands clasped in prayer in front of a pedestal on which there lies a dead rat. The second also shows a youthful man in a bridal veil. His chest and torso are bare, but he is wearing a white skirt. He stands to the left of a large cross set up in the open countryside. On the other side of the cross stands a nude baby. If *The Guitar Lesson* is a blasphemous paraphrase of the *Avignon Pietà*, this is an equally disturbing and unorthodox version of a Crucifixion with the Madonna and St John.

Balthus's style, as opposed to the actual content of his work, has been painstakingly analysed by Rewald. She points out that while some elements come from his study of early Renaissance artists such as Piero della Francesca and Masaccio, others are taken from less august sources. For example, the young Balthus was much influenced by a cycle of paintings by the minor Swiss artist Joseph Reinhardt showing Swiss peasant costumes. These, painted between 1787 and 1797, are now in the Bernisches Historisches Museum. They have a stiff archaism which makes them very unlike the metropolitan French art of the same epoch – David's *Oath of the Horatii* and *Marat assassiné* both fall within the same period. Other Balthus sources include nineteenth-century *images d'Epinal* (French popular prints) and illustrations in old German children's books, such as Heinrich Hoffmann-Donner's *König Nussknacker und der Arme Rein-*

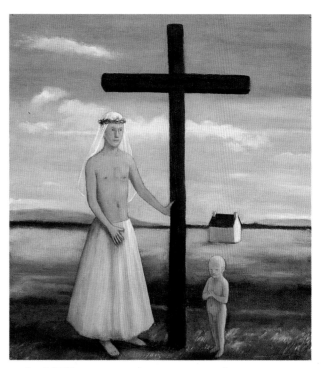

The Dead (1993), oil on board, 51 × 46 cm (20 × 18″), Courtesy Angela Flowers Gallery

hold, published in Frankfurt in 1851.

I am not suggesting that Kirby has responded to precisely the same range of influences – many of those listed would have been far more accessible to a continental artist of Balthus's generation and background. What I am saying is that we have clear evidence of a sensibility attuned to the same spectrum of ideas.

Many small details help to confirm the affinity. Both artists, for example, are fascinated by the significance of playing-cards, which appear in their paintings as symbols of fate and also sometimes as emblems of power. Both make much play with mysterious openings: doorways and windows. Both are fascinated by mirrors. Like the playing-cards, these add a distinctly ominous tone.

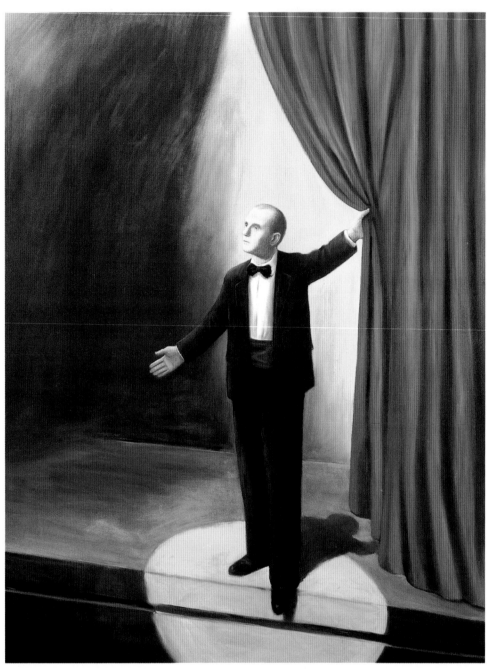

Master of Ceremonies (1989), oil on canvas, 204 × 158 cm (80¼ × 62¼"), Collection Morrison, Cohen, Singer and Weinstein, New York

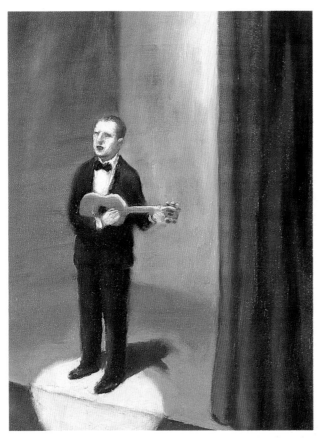

The Entertainer (1989), oil on canvas, 56 × 46 cm (22 × 18"),
Collection the Artist

It is also significant that both artists make a rather similar use of nudity. Balthus's nudes, always female, are vulnerable yet at the same time self-contained. Kirby's, usually but not invariably male, tend to have the same qualities, though there are occasions on which he uses nudity in a different and more brutal way. *State of Grace* (1991) shows a naked, unsexed child clutching a rosary – one of Kirby's more forthright comments on the Catholicism in which he was brought up.

XVI

There is one other artist who seems to have had a decisive impact on Kirby's work, and this is the American Realist Edward Hopper. Hopper is an odd-man-out in American art, just as Kirby is amongst the British artists of his own generation. He is one of the few American figurative painters of the Modernist epoch who seems to have been little influenced by photography. In this he differs from the Precisionists who were his

contemporaries, and from the Super-Realists who later took over some aspects of his subject matter.

It has often been remarked that Hopper's prime subjects are loneliness and lack of communication. When he expresses these through landscape, as for example in *House by the Railroad* (1925), generally held to be the earliest example of his mature style, he and Kirby seem to have little in common. But the resemblance between some of Hopper's paintings with figures and Kirby's is often quite striking, and it is no surprise to discover that Kirby considers him to be the greatest American artist. For Kirby, a personal favourite amongst his own works is a theatrical scene, *The Entertainer* (1989, originally entitled *The Journey of the Soul*). A self-portrait-like figure is shown standing in a spotlight on the very edge of a stage, playing the ukelele. It is a direct response to Hopper's *Two Comedians* (1965), where two actors in pierrot costume, spotlit at the edge of the stage, are taking a bow.

Hopper also, like Kirby, paints figures which are isolated in anonymous spaces – hotel rooms are a favourite location – or, if there are two or more figures in the same space, then very often they seem to ignore one another, just as Kirby's personages do.

These resemblances are reinforced by a certain similarity of technique. Hopper's paintings offer more detail than Kirby's, more attention is given to accessories, furnishings, details of costume. It is these which entitle Hopper to be labelled 'Realist', while one would hesitate to apply this label to Kirby, no matter how far the adjective has now been stretched. The realist details are, however, rendered by Hopper in a blunt, dry-textured way which is in many respects similar to Kirby's typical facture. A Kirby hung beside a Hopper, like a Kirby hung beside a Balthus, would be in harmony with its companion: all three artists have much the same approach to the whole business of putting paint on canvas. They use the painter's materials directly and without fuss, as a means to an end.

XVII

The whole business of comparing one artist to another now tends to arouse hostility in part of the audience for art. If, when examining the work of a particular painter, the critic discovers likenesses to, or even borrowings from, other artists, this is held to be a slur on the originality of his subject. This is a foolish and naïve view, justified only by the extremes to which the modern cult of genius has now been taken. The supposition is that the contemporary artist must be absolutely *sui generis* if his or her work is to have any value. The paradox is that Kirby's links and homages to a handful of painters working in the recent past, almost all of them somewhat out of the mainstream, are really a kind of guarantee of his stubborn uniqueness in the context of late-twentieth-century art. He is trying to re-establish a tradition, in addition to expressing concerns which are purely personal.

This leads one to look at the main categories into which his own production can be divided. Unlike many contemporary painters, much of Kirby's work is quite

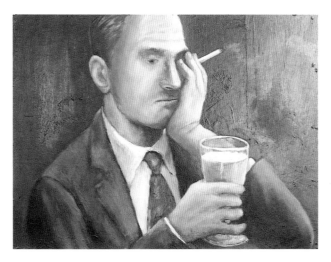

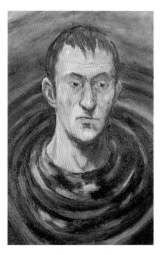

Man in a Bar (1987), oil on board, 25.5 × 35.5 cm
(10 × 14″), Private Collection

Not Drowning (1987), oil on canvas,
64 × 47 cm (25¼ × 18½″),
Private Collection, USA

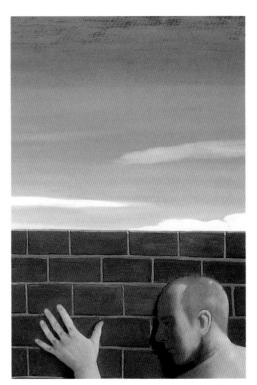

Love (1991), oil on canvas, 90 × 60 cm (35½ × 23½″),
Private Collection

modest in size. The smallest paintings gen-erally feature single heads, often with some distinguishing mark, attribute or symbol which gives the work a particular nuance. Some of the heads are clearly self-portraits, others are what one might call 'adapted self-portraits', based on Kirby's own appear-ance, but not naturalistic images. Often the head is used to reflect a very specific mood – *Man in a Bar* (1987) is a Kirby-like indi-vidual with a glass of beer and a cigarette. His mouth is drawn down, one hand is pressed to his face, and his general demeanour is expressive of deep depres-sion. Yet it is also clear that the artist is dis-tancing himself from what is shown. The statement the painting makes is not 'I was depressed when I did this', but 'This is what it is like to be depressed'. And it is made with a sardonic edge. There is similar irony in other paintings. In *Not Drowning* (1987), the Kirby-surrogate looks as if he is about to be overwhelmed by the water rising about him. The title, however, seems

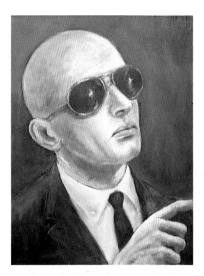

Iceman (1986), oil on canvas, 76 × 61 cm
(30 × 24″), Collection Don McLeod

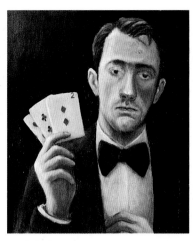

Man of Magic (1987), oil on canvas,
59.5 × 68.5 cm (23½ × 27″),
Collection Ian Thomson

to suggest that this semi-submerged state is his natural condition. *Love* (1991) is more crudely symbolic: the protagonist, now seen in profile, presses a hand against an unyielding brick wall.

The most resonant and disturbing of these self-portraits, or near self-portraits, are those in which one finds the religious preoccupations also evident in a number of Kirby's more elaborate compositions. In one, composed like the wing of a Flemish fifteenth-century diptych, the Kirby-figure, seen in three-quarter profile, raises clasped hands in prayer, as if looking towards the missing leaf which would contain the Madonna. In the background, filling the rest of the picture-space, is a tower. It echoes the buildings sometimes seen in Flemish prototypes, but can also be read as the guard-tower of a modern concentration camp or prison. Yet more unsettling is a painting entitled *Opus Dei* (1992). Here the figure once again makes a depressive gesture, pressing a hand against its cheek. The hand is marked with the stigmata.

Related to *Opus Dei*, but less portrait-like, are a group of heads where the personage is completely bald and egg-like – the absence of hair, in this case, perhaps being a metaphor for nakedness. In two cases, this bald creature has the sign of the cross branded on his forehead. In another more recent small painting, the personage wears an earring. Kirby says that he began this before hearing of the death of his father, and finished it afterwards, when he was still absorbing the shock. The earring is a discreet allusion to the theme of androgyny which appears in a number of other paintings, and the features are more particularised, as if to bring them closer to

Kirby's own appearance.

The men and boys with bald heads, however, are not invariably mirrors for the self. An early example, *Iceman* (1986), which shows a man with a totally shaved skull wearing a business suit and a pair of sinister dark glasses, is intended – both expression and gesture make this obvious – as a statement about human qualities the artist rejects and dislikes. There is a link, perhaps a coincidental one, to the long series of *Goggle-Head* sculptures by Elisabeth Frink, which Frink saw as allegories of the inhumanity of the modern world. She based them on news photographs and that may possibly be the source here.

Iceman belongs to a group of small paintings where the head is used as a way of summing up a type of situation. *Man of Magic* (1987) holds up three cards, like a conjurer about to perform a trick. In *Prospect of the Sea* (1988), the subject is seen in profile, with a white rat riding on his shoulder. Kirby has said that this rat, which also appears in other, more ambitious, paintings, can serve the function of an *alter ego*. In this context, however, it also takes on an emblematic air. One thinks of Renaissance portraits where the sitters are portrayed holding symbolic animals – Holbein's *Lady with a Squirrel*, Leonardo's *Lady with an Ermine*. Indeed, the whole schema is reminiscent of an established category in Renaissance portraiture: of profiles on medals, and portraits by Signorelli and Domenico Veneziano. Perhaps the closest comparison is Piero della Francesca's powerful likeness of *Federigo da Montefeltro, Duke of Urbino*, now in the Uffizi. Even the background Kirby has chosen serves to

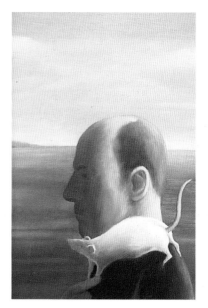

Prospect of the Sea (1988), oil on board, 61 × 30.5 cm (24 × 12″), Private Collection

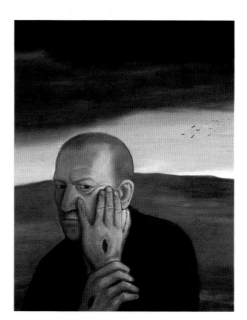

Opus Dei (1992), oil on canvas, 54.5 × 44 cm (21½ × 17¼″), Courtesy Angela Flowers Gallery

drive the comparison home, since the backdrop for the duke's likeness is a distant lake.

Once one has become attuned to the sly allusions Kirby uses, they manifest themselves everywhere. *Portrait of a Man* (1988), a likeness of an African or Afro-Caribbean man holding a small yellow flower, is a bold, ironic paraphrase of Dürer's famous *Self Portrait* of 1500, in which he assimilates his own appearance with the traditional image of Christ. The man's expression, his strictly frontal pose, and even the position of his hand are all very much the same. Yet the references do not in any way compromise the modernity of Kirby's psychological depiction, any more than similar references and quotations do in Balthus.

XVIII

The paintings by Kirby which come closest in emotional tone to his small portraits might be loosely described as 'domestic scenes'. One or two,

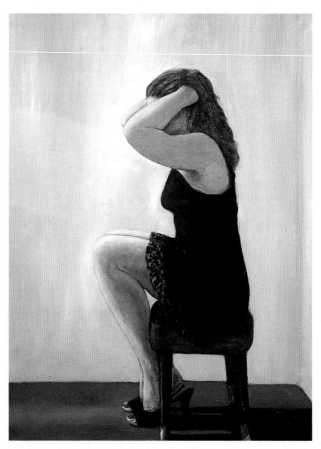

A Woman's Room (1985-90), oil on canvas, 110 × 82.5 cm (43 × 32½"),
Collection Mr and Mrs Carmichael

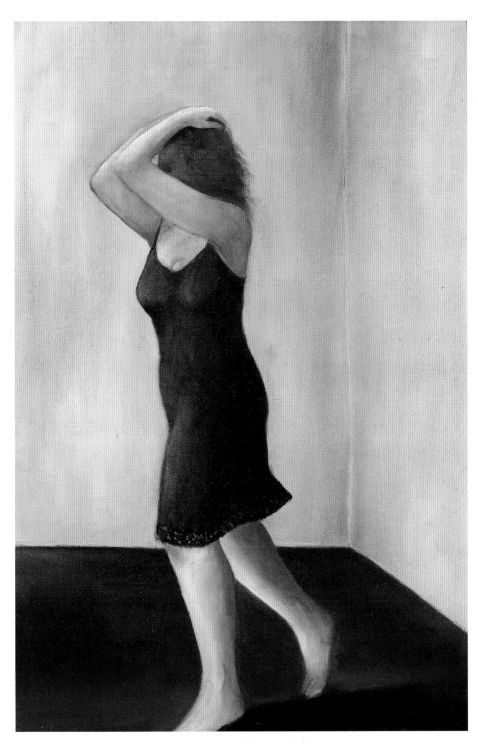

Untitled (1988), oil on board, 92 × 61.5 cm (36¼ × 24¼″), Private Collection

such as the painting of a couple dancing while a young man in the same room firmly turns his back, have already been described. Early works of this type were amongst the least typical Kirby has produced. Two works from 1985 – one now substantially altered, the other destroyed – fall into a special subgroup. *Woman Sitting* (repainted in 1990) shows a girl in a black camisole, seated in profile, raising her arms to clutch her hair. The destroyed painting, which remains untitled, showed a young man in a white sleeveless vest and trousers entering a room where a woman in a long black gown stands waiting. What was uncharacteristic about these works was their attempt at painterliness. Kirby has apparently been looking at Bonnard as well as at Balthus. The result, as he soon realised, was a dilution of what he had to say. Yet both paintings are clearly related to what comes later. This is especially true of the untitled work. The woman in the long gown stood in a posture which was stiff and menacing, dangling a rosary between her fingers. By contrast, the youth

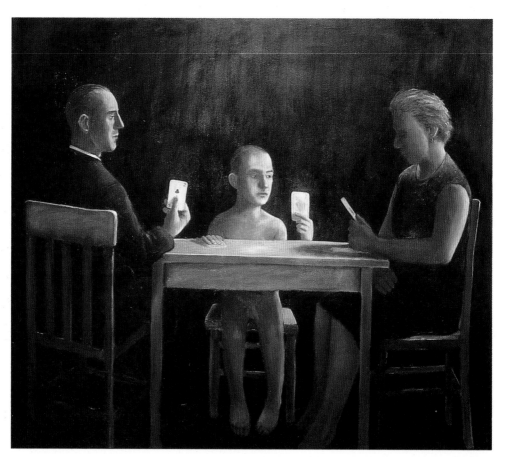

The Company of Strangers (1987), oil on canvas, 157 × 179.5 cm (62 × 70″), Collection Susan Kasen Summer and Robert D. Summer

entering the room was subdued and shamefaced. On his right shoulder there was a bluebird tattoo which the artist still often uses to indicate that the figure is a surrogate for himself.

Woman Sitting, though the less successful of the two paintings, is important for what it tells us about Kirby's close relationship to Balthus. The key reference is to a Balthus painting of 1955, now in the Metropolitan Museum, New York. This shows a nude girl striding towards a mirror which is propped on a mantelshelf. As she does so, she gathers up her hair in both hands, using exactly the same gesture as the one portayed in *Woman Sitting*. Evidently not satisfied with this version of the motif, Kirby later made an even closer paraphrase of the Balthus. *Woman with a Dog* (1989) shows a clothed girl in profile, standing in the same position as Balthus's nude, facing to the left, and lifting her hair with an almost identical gesture. The difference is that it is now eloquent, not of self-satisfaction and vanity, but of despair.

More recently still, Kirby has made a third and much freer version of the same composition. The female figure, which in this case he identifies as a portrait of his sister, now faces right, and reaches towards a plastic washing-up bowl set on a small table. If one knows the source, the painting reads as a deliberately sardonic comment on the glamour of the Balthus. It also reads as self-criticism: the despairing emotions of his own two previous versions are rejected as sentimental.

The best of Kirby's 'domestic' pictures have an element of fantasy, combined with allegory, which lifts them out of the mundane sphere. Their subject, nearly always,

is family relationships, specifically his own relationship with his parents. *The Company of Strangers* (1987) shows three people – a man, a woman and a young boy – playing cards. It is a variation of a motif which recurs in European art, from the end of the sixteenth century to the end of the nineteenth. Among the best known versions of the theme are Caravaggio's *The Cardsharps*, recently rediscovered and now in Fort Worth; the two versions of Georges de La Tour's *The Cheat*; and the various versions of Cézanne's *The Card-Players*, among them the masterly one in the Barnes Collection.

Kirby follows Caravaggio and Georges

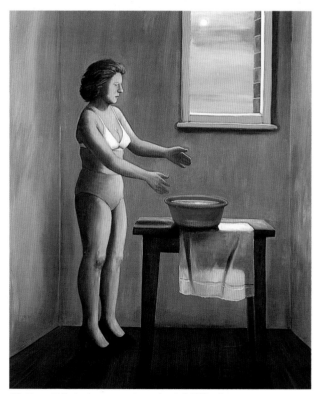

Silly Fears (What's done cannot be undone) (1990), oil on canvas, 188 × 153 cm (74 × 60¼"), Courtesy Angela Flowers Gallery

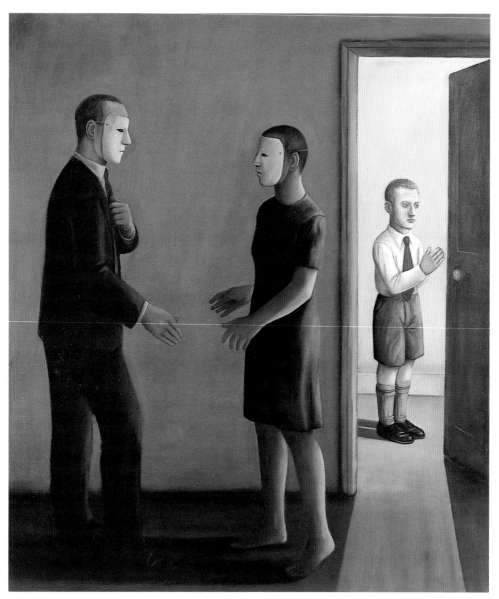

Nightwatch (1989), oil on canvas, 215 × 183 cm (84¾ × 72″), Collection Susan Kasen Summer and Robert D. Summer

de La Tour by giving the card game symbolic significance – the game is also the game of life – but does not moralise as blatantly as they do: the whole question of winners and losers remains obscure. The tenebrous lighting of the picture and the intent gravity of the personages show that Kirby was keenly aware of seventeenth-century Caravaggism when he painted it.

Two other very powerful paintings about family life are less literal. One is *Nightwatch* (1989). This shows a masked couple dancing in a darkened room, while a boy listens, rather than watches, through an open door. The composition is an extraordinarily powerful metaphor for the child's discovery of the sexuality of his parents. The boy is witnessing or, rather, eavesdropping upon a version of what Freud tactfully calls 'the primal scene'. Yet the painting also suggests something else, equally important: that the two adults remain mysterious to and alienated from one another, as well as from their offspring.

A Holy Family (1988) is equally haunt-

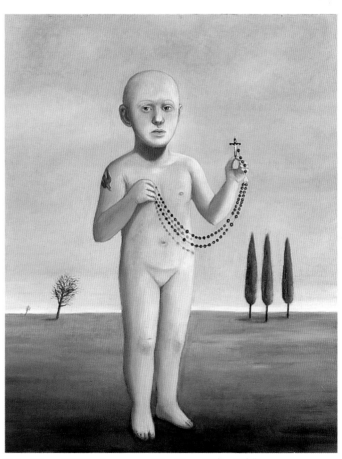

State of Grace (1991), oil on canvas, 90 × 70 cm (35½ × 27½"),
Private Collection

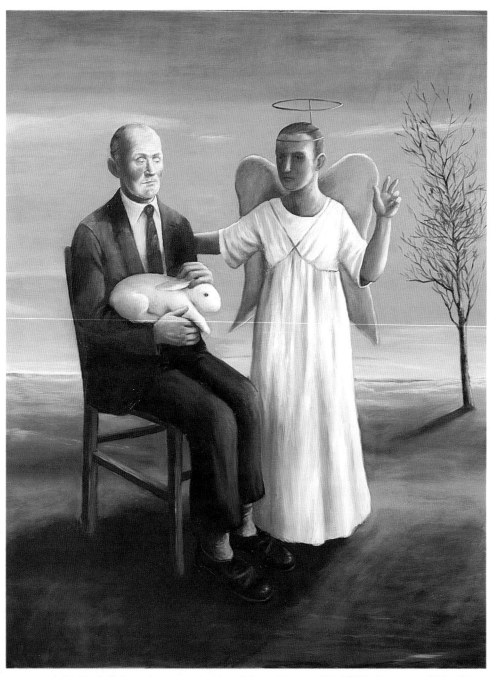

A Holy Family (Self-portrait as an angel, with my father and his pet rabbit) (1988), oil on canvas, 204 × 158 cm (80¼ × 62¼″), Private Collection

ing, though harder to interpret – this, despite the fact that the artist, contrary to his usual practice, has supplied a subtitle: *Self-portrait as an angel, with my father and his pet rabbit.* What can we deduce from the image and the words attached to it? First that, as the arrangement of the figures suggests, this is a version of a standard *Holy Family*, consisting of Mary, the baby Jesus and a protective St Joseph. However, the youthful mother is now an old man, the Saviour has become a family pet and Joseph is a boy in fancy-dress. The title also implies that this is a family which aspires towards the condition of holiness.

Perhaps the old man offers the easiest clue: despite its rock-solid dignity, the image tells us that the father is vulnerable – he has become someone to be nurtured and protected. The boy is doing his best. His *ad hoc* costume is the kind of thing a schoolboy might don for a school nativity play; it is a sign that he is trying to 'be an angel', to respond to the adjurations of parents and teachers, without fully succeeding. The rabbit is both usurper and alter ego: a stupid, limited, comfortable, manageable version of the boy. So one possible interpretation of the picture is to see it as a meditation on the religious upbringing from which Kirby has grown away. At the same time, perhaps, he wants to protect his father from the full knowledge of that growing away. Like most resonant visual images, this one will allow several different interpretations.

XIX

Linked to these 'family' images are several which are more directly allegorical commentaries on childhood. In *Untitled* (1987) a bald child, identified as Kirby himself by the presence of the bluebird tattoo, strikes a knowing, slightly aggressive pose, arms folded across his chest. The message seems to be that children know much more than adults think, and become impatient and judgmental over what is said and done to them. *State of Grace* (1991), one of the artist's most alarming images, is yet more confronta-

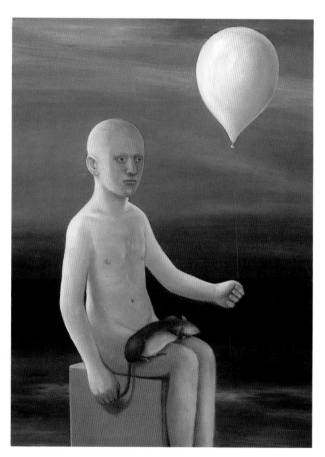

Day into Night (1990), oil on canvas, 102 × 76 cm (40¼ × 30″), Courtesy Angela Flowers Gallery

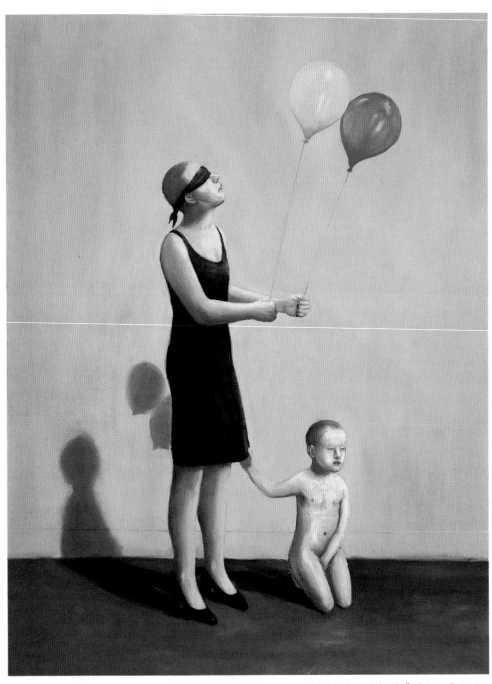

The Blind II (1990), oil on canvas, 122 × 91.5 cm (48 × 36″), Private Collection

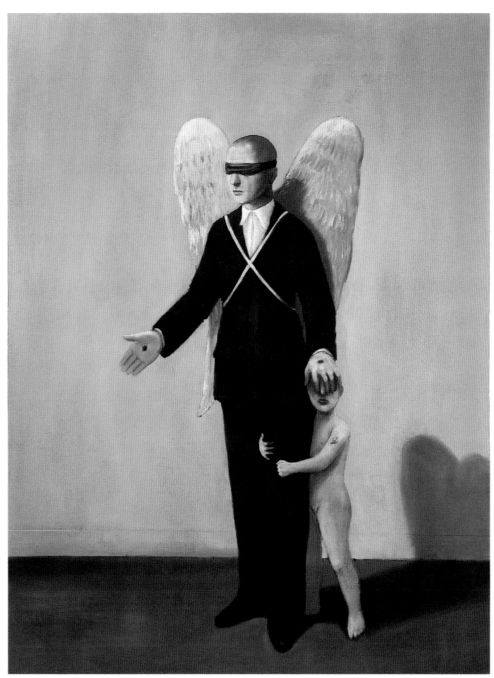

The Blind (1990), oil on canvas, 122 × 91.5 cm (48 × 36″), Private Collection, Wales

tional. The bald, tattooed child reappears, now at an earlier stage of his physical development. He is holding a rosary and, though completely nude, has no sexual organs. That is, he has been completely unsexed by religion. *Day into Night* (1990) offers yet another nude, bald child, seated in a landscape. On his lap there is a rat, either dead or sleeping, whose tail he holds lightly in the fingers of one hand. The other hand clutches the string of a helium-filled balloon, which bobs in the air in front of him. Though the subject's face is stern and judgmental, matching the formal rigidity of the pose, which is like that of an Egyptian pharaoh, the actual content of the painting seems to be a little more hopeful than that of those just described. The balloon in Kirby's work is often a symbol of hope, though sometimes there is also the suggestion that the hope may be misleading or is unlikely to be fulfilled. In *The Blind II* (1990) a baby kneels and covers its genitals, meanwhile tugging at the skirt of a blindfolded woman who holds two balloons. This originally formed the left half of a diptych, the right half being *The Blind* (1990), where a male figure in a suit, equipped with property wings, is accompanied by a nude, blindfolded child who clings to his leg. The paired pictures seem to take a jaundiced view of human aspiration, since the only person who can see clearly is the youngest of the four. Yet they do not suggest a world entirely without hope: there is sly humour in their depiction of the human tendency towards self-deception.

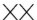

One painting occupies a special position in Kirby's work, because of the way in which it unites themes from several different groups. This is *The Sea* (1988). In it, two figures are seen wading knee-deep in the waves. One is a man in a suit – his face is turned skywards, but his eyes are closed. With him, holding on to his sleeve, and putting the forefinger of his other hand into his mouth with a gesture of bewilderment, is a boy, a child just on the threshold of adolescence. He is nude but for the kind of paper crown one might find in a Christmas cracker. The sea is the theme of one whole series of paintings; the paper crown dominates another.

In the painting just described, and in a number of other works, the waves seem to symbolise a blind, inexorable force, a tide of events which takes people unawares. Sometimes they are entirely swallowed up. *Deep Water* (1989) shows a man apparently about to sink unresisting. Sometimes the sea is a force that terrifies them. In *Water's Edge* (1988), a clothed man leaps, panic-stricken, into the arms of a companion, apparently desperate to get away from the threatening element. In the background, quite at ease, there is a third figure, clad in a bathing suit.

Sometimes the sea represents division or danger. In *A Gap Between the Cliffs* (1991), two men, each perched on the top of a cliff, gaze at one another across a chasm. In *Going On* (1990), a man carries a child on his shoulders, walking along the very edge of a precipice, while the child covers the man's eyes with his hands. This

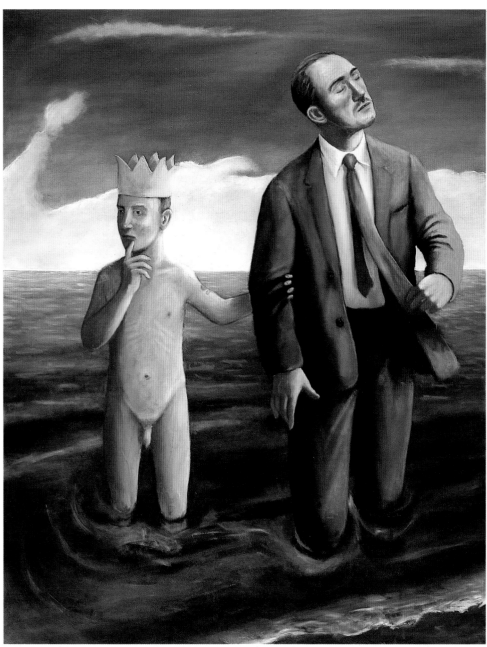

The Sea (1988), oil on canvas, 202 × 156 cm (79½ × 61½″), Collection Robert and Mary Moriarty, Chicago, Illinois

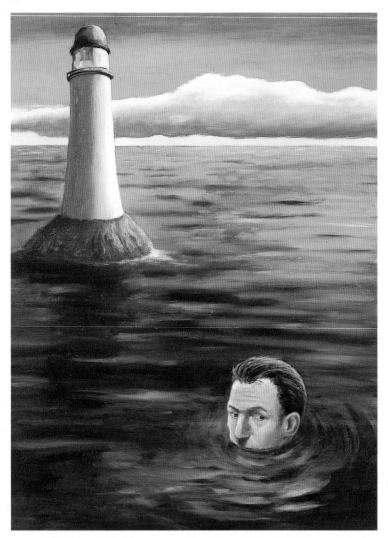

Deep Water (1989), oil on canvas, 124 × 90.5 cm (48¾ × 35½″), Private Collection

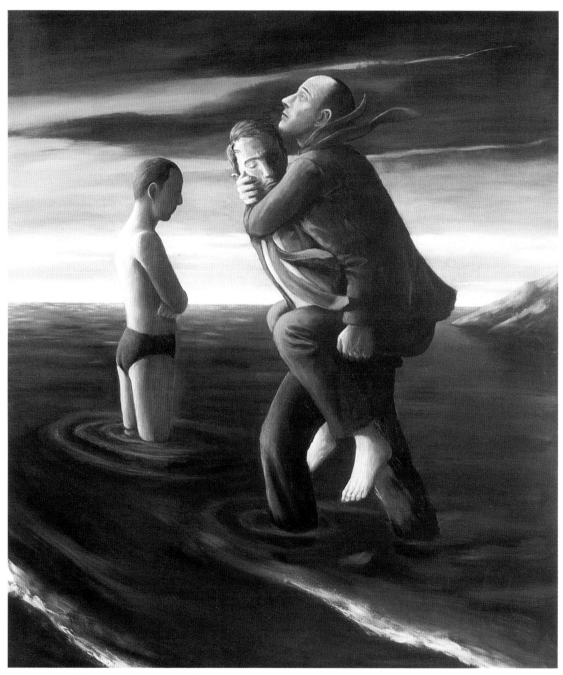

Water's Edge (1988), oil on canvas, 213.5 × 183 cm (84 × 72″), Collection Susan Kasen Summer and Robert D. Summer

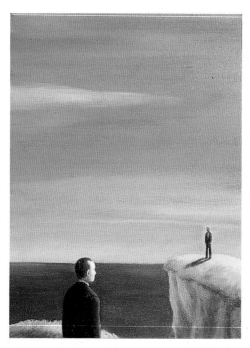

A Gap between the Cliffs (1991), oil on canvas,
49.5 × 39 cm (19½ × 15¼″), Private Collection

home with this perilous situation.

The 'paper crown' pictures, which are amongst the most touching Kirby has ever painted, are much less easy to interpret in symbolic or allegorical terms. A great deal of their power comes from the quiet, mildly melancholy mood which they distil. Kirby says that the idea for them came from a trivial incident. A friend snatched up just such a paper crown and crammed it on his head. He then caught a glimpse of himself in a mirror, with an expression completely at variance with such light-hearted adornment. *Boy in a Paper Hat* (1988) makes the point very simply: the subject sits, upright but relaxed, wearing a curiously solemn expression, the mask of one who is about to assume heavy responsibilities (perhaps these are the responsibilities of adulthood). In *A Death Foretold* (1988) what might be the same boy looks at himself in a mirror. One is reminded of the famous self-pitying speech made by Shakespeare's Richard II:

> All murder'd: for within the hollow crown
> that rounds the mortal temples of a king
> Keeps Death his court, and there the antick sits,
> Scoffing his state and grinning at his pomp;
> Allowing him a breath, a little scene,
> To monarchize, be fear'd, and kill with looks,
> Infusing him with self and vain conceit
> As if this self that walls about our life
> Were brass impregnable; and humour'd thus,
> Comes at the last, and with a little pin
> Bores through his castle wall, and farewell
> king!
>
> *Richard II*, Act II, Scene i

In *Family Ties* (1988) the same boy – almost certainly – sits rigid on a chair in a darkened room. Just beyond him is a doorway, opening into a much lighter space.

latter image is clearly a contribution to the ongoing debate, found in so many of Kirby's paintings, about the problematic relationship between childhood and adulthood. A number of paintings, such as *The Blind* and *The Blind II*, state flatly that adulthood is a condition of blindness. *Going On* suggests that the adult is blinded by the child he used to be – presumably by the experiences that child has undergone in the process of growing up.

Other 'sea' pictures are less pessimistic. The man in *The Headland* (1989) stands at the very edge of a cliff, but actually seems to rejoice in his position of danger. Another man, in *The Birdless Sea* (1989), is less exuberant, but ventures to the edge to look mildly into the abyss. The dog which accompanies him seems equally at

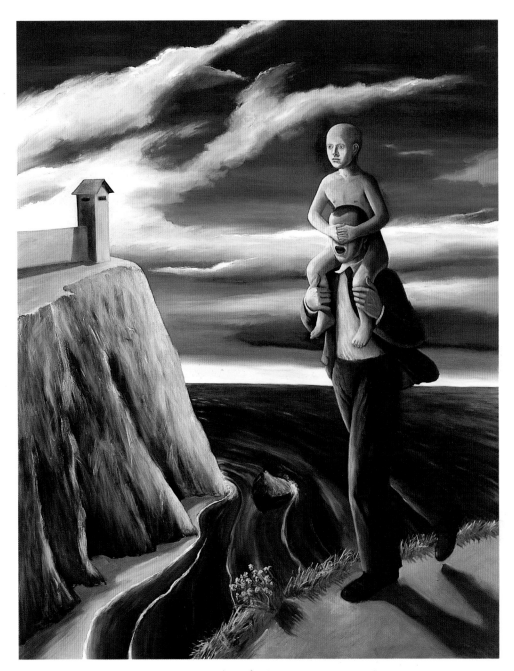

Going On (1990), oil on canvas, 240 × 180 cm (94½ × 70¾), Courtesy Angela Flowers Gallery

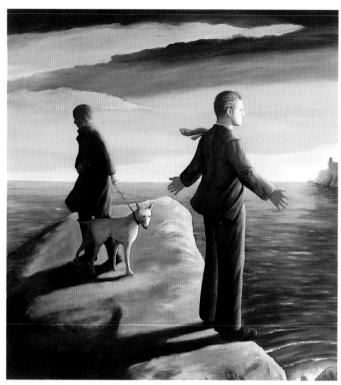

The Headland (1989), oil on canvas, 198 × 183 cm (78 × 72″), Private Collection

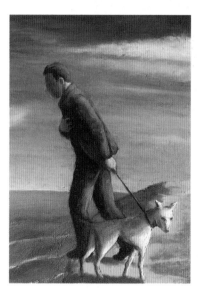

The Birdless Sea (1989), oil on board, 53 × 42 cm (20¾ × 16½″), Collection Matilda Tumim and Christopher Prendergast

His alert pose and strained, troubled expression suggest that he is eavesdropping, and the title itself prompts the thought that what is heard is some kind of family discussion or quarrel. Here the crown might perhaps be interpreted as a symbol of the juvenile egotism which, at a certain age, makes us relate all events within the family group directly to ourselves.

A final painting – perhaps not actually the last in the series, but the last in the narrative sequence I have constructed here – shows the subject as a young adult, seated in the same pose as the figure in *Family Ties*, but in an even darker space, apparently without the possibility of escape. He is

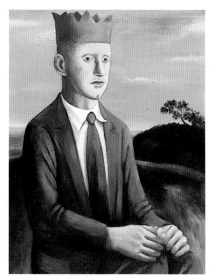

Boy in a Paper Hat (1988), oil on board,
84 × 63 cm (33 × 25″), Collection the Artist

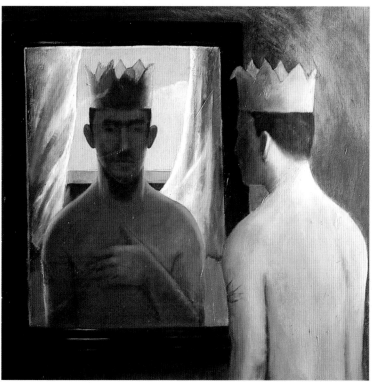

A Death Foretold (1988), oil on canvas, 101.5 × 101.5 cm (40 × 40″),
Collection Amanda Faulkner

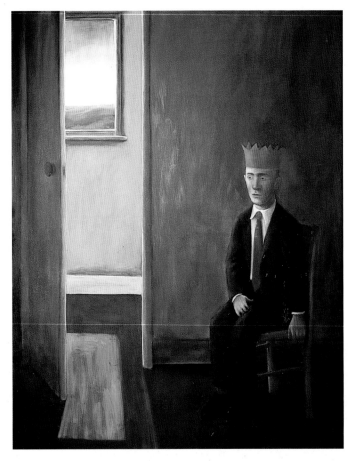

Family Ties (1988), oil on canvas, 207.5 × 159 cm (81¾ × 62½"),
Private Collection, USA

accompanied by that most familiar of Kirby alter egos, a pet rat, and his expression and some subtle shifts in posture suggest more ease with the ridiculous paper crown which sits on his head, but less hope.

XXI

The paintings which deal with family life, and with the painful process of growing up, can be contrasted with others, which deal less obliquely with sexuality. Basically, they fall into two main groups. There are paintings which show male-male couples, and there are others which deal with gender and gender-confusion.

Men dancing together appear often in Kirby's work, and it is astonishing how many variants he has found for this apparently simple theme. The couple can be of mixed race (*Two Men Dancing*, 1986). They can be wearing prison stripes (another painting of the same title and the

Two Men Dancing (1986), oil on board,
85 × 50 cm (33½ × 19¾″),
Courtesy Rupert Blunt Fine Art

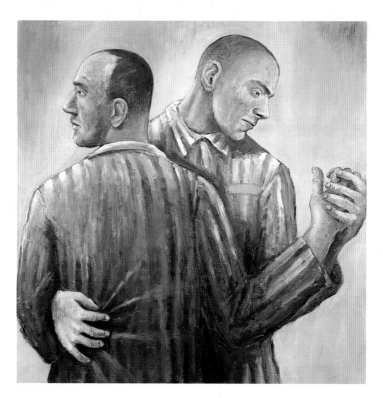

Two Men (1986), oil on board, 102 × 100 cm (40¼ × 39¼″), Private Collection

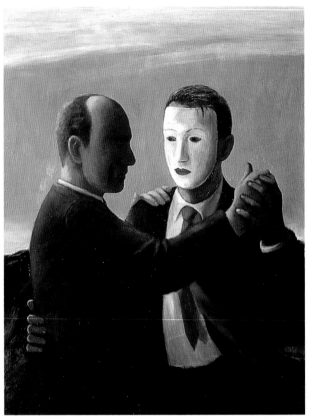

Secret Lives (1988), oil on board, 106.5 × 78 cm (42 × 30¾"),
Heller Collection

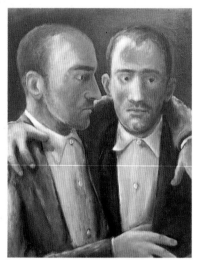

Two Men (1987), oil on board,
45.5 × 30.5 cm (18 × 12"), Private Collection

same year). One of them can be masked (*Secret Lives*, 1988). The painting can be a close-up, so that the spectator is not sure if the men are dancing or embracing (*Two Men*, 1987). Or the embrace can be passionate and apparently whole-hearted (*Untitled*, 1991). In each of these compositions there is a typical element of commentary, and an even more typical element of doubt. The men in prison stripes look away from one another, and their clothing suggests their outcast status. The white man dancing with a black man wears dark glasses which hide his expression. These dark glasses, in *Secret Lives*, are replaced by the mask which, significantly, is worn by a younger man dancing with an older one. The implication, reinforced by the title, is that they are together, and yet separate – separated from the rest of society and also from one another. In *Untitled* (1991), the man with his back to us seems to hug his partner possessively; but the posture of the one facing us is rigid, and his expression – lips compressed, eyes turned away and staring blankly out of the picture – is one of sorrow and doubt.

While one should never rush to impose interpretations on Kirby's paintings, it seems obvious that the images of men

dancing are intended to reflect the plight of the homosexual in contemporary society. What the artist seems to be saying is that males who attempt to bond with males are not only alienated from what surrounds them, but are also in some way still profoundly alienated from one another, however close and powerful the emotional links they try to create. This interpretation is reinforced by a number of other paintings with a greater degree of specific narrative content. *At the Cross* (1993) uses a metaphor which is becoming increasingly frequent in Kirby's work: it places the figures at a vast distance from us, dwarfed by the surrounding landscape, in this case, a green but treeless scene which may have been inspired by the west of Ireland, where the artist now lives and works. Two men, clad identically in dark clothes, are embracing at a crossroads. One looks over his shoulder, as if already thinking of the road he has to travel alone. The spectator's distance from the action depicted becomes a way of expressing the inevitability of separation.

The Kiss (1990) is more specific, and comments on Catholic repression of homosexual feeling. Two young men, fully-clothed but barefoot (to suggest furtiveness), touch cheeks. The scene is a corridor, with a crucifix hanging on the wall. In *Secret Places, Private Parts* (1988/89), the actors are an older (but not old) man and a youth. The man, fully clothed and blindfolded, is blundering his way round the room they both occupy, feeling his way with outstretched hands. The youth, wearing only underpants, is standing at the window, staring out. The sash is partly raised, and makes the single curtain flutter in the breeze.

The atmosphere distilled by *The Kiss* is one of guilt. In *Secret Places, Private Parts*

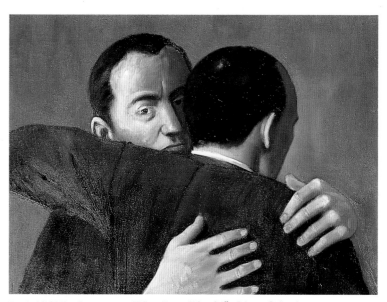

Untitled (1991), oil on canvas, 45.5 × 61 cm (18 × 24"), Private Collection

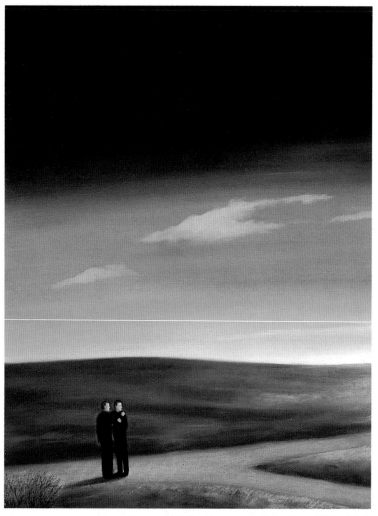

At the Cross (1993), oil on canvas, 101 × 75 cm (39¾ × 29½″),
Courtesy Angela Flowers Gallery

the theme is not guilt but separation, mis-understanding, and the way that two peo-ple in an unviable relationship oppress one another. The youth, it is clear, understands his situation and wants to escape from it. He has deliberately turned his back on his companion. His scanty clothing may express lack of material means, as well as the possession of sexual attractiveness. The wind coming through the window is the tantalising wind of freedom. The older man has no idea what his companion is thinking. He also, and in the most literal sense, has no idea about where they both stand. To him, the emotional space they occupy remains a mystery.

There is one more painting which belongs to this group, and it, too, features a window. Entitled *Still Lives* (1989), it shows a man – Kirby's familiar suited fig-

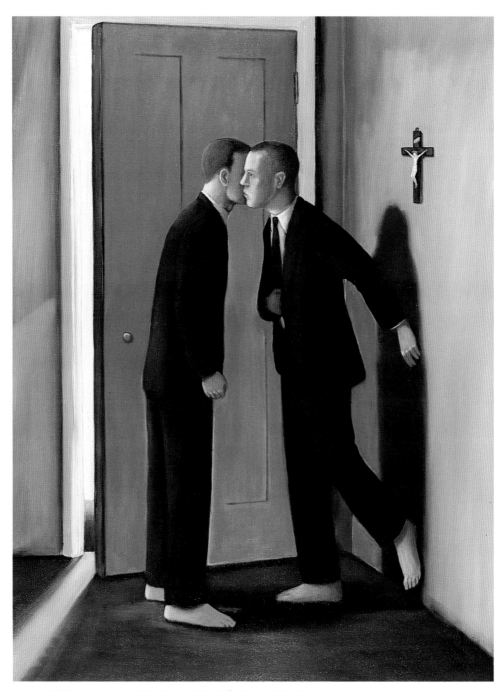

The Kiss (1990), oil on canvas, 122 × 91 cm (48 × 36″), Private Collection, Italy

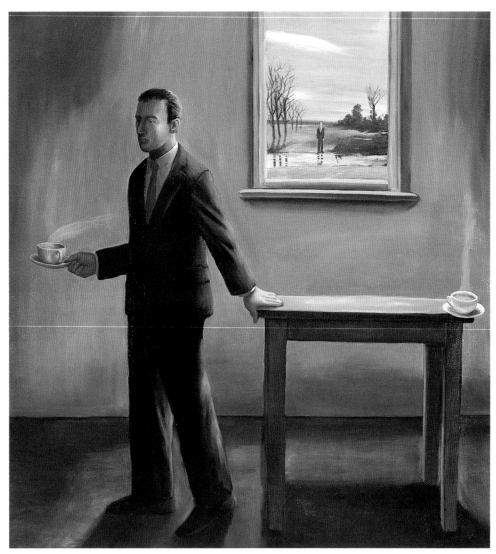

Still Lives (1989), oil on canvas, 198 × 182.5 cm (78 × 72″), Courtesy Angela Flowers Gallery

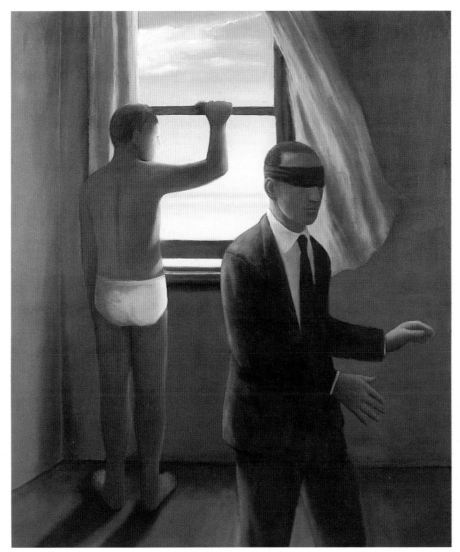

Secret Places, Private Parts (1988/1989), oil on canvas, 159 × 133 cm (28½ × 52¼"),
Courtesy Angela Flowers Gallery

ure – in a room. In his outstretched hand he carries a cup of tea. Another cup of tea is balanced, very precariously, at the edge of a small table. The slightest push or shake will make it fall. Through a small window, directly above the table, we see a landscape, with a second, miniature figure standing on the other side of a stream, looking at it as if unable to get across. The story here seems to be one of a relationship in suspense, but just about to fall apart. The partners are already separated, but one of them at least is unaware of it. The crash is still to come.

XXII

The paintings just described illustrate Kirby's talent for symbolic narrative, and the concision and economy of means he uses to put the intended meaning across to the spectator. If they have a fault, it is that they are a little too specific; there isn't a sufficient play of ambiguity.

This cannot be said about the pictures whose theme is gender. In my view these

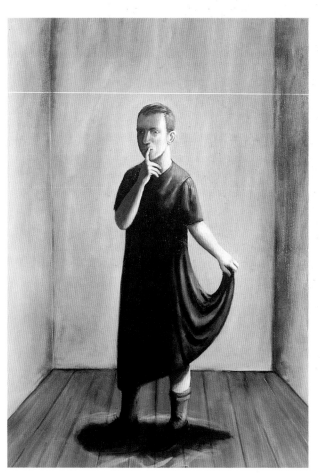

Boy in a Black Dress (1989), oil on canvas, 180.5 × 124.5 cm (71 × 49"), Collection Susan Kasen Summer and Robert D. Summer

are Kirby's most extraordinary and haunting works. Here again there are two subdivisions. The first of these consist of a series of paintings in which men appear in women's clothing. I have already written, in passing, about several of these, including the haunting *Self-Portrait* which shows the artist in female clothes. One strap of his dress has slipped down to reveal his trademark tattoo, a rose is thrust into his corsage, and his right hand is raised in the gesture of blessing familiar from paintings of Christ as the risen Saviour. Not surprisingly, Penguin chose this image for the cover of their paperback translation of Jean Genet's *The Miracle of the Rose.*

Kirby's transvestite paintings are intimately linked, both formally and thematically, with the rest of his work. *Inner Voices* (1988), for example, is a very free version of the Balthus painting already described, showing a nude girl looking at herself in a mirror, which has also served as the basis for several other works. The figure is seen in profile, facing left and taking a pace forward, just as the girl in the Balthus painting does. But there is no mirror, and this, despite his clothing, is undoubtedly a man, with the cropped hair and tattoo of the *Self-Portrait.* From the left hand dangles a rosary, one of Kirby's standard emblems of preoccupation with religion, and specifically with Catholicism.

In all the paintings in the group – *Self-Portrait* and *Inner Voices* are just two examples – the protagonist, despite wearing female clothing, remains indisputably male. Often there is the suggestion that clothing is simply a visible manifestation of

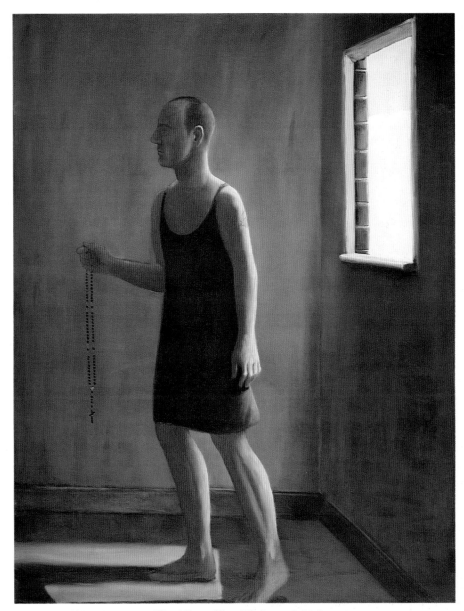

Inner Voices (1988), oil on canvas, 198 × 152 cm (78 × 60″), Sutton Collection

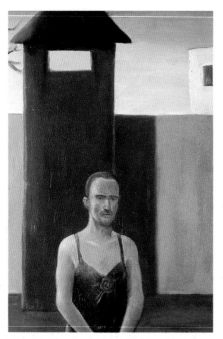

The Tower (1987), oil on board,
48.5 × 33 cm, (19 × 13″), Collection Jacqueline
and Campbell Bruce, Ireland

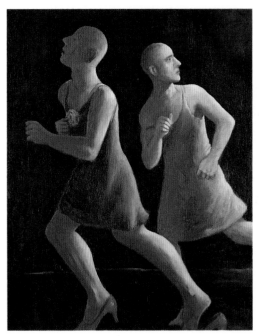

Running Away (1987), oil on canvas, 91 × 73 cm,
(35¾ × 28¾″), Private Collection

sexual feelings which till then have remained secret. That is, we are encountering the figures, not as they would appear to us in real life, but as they would appear to themselves, in their own dreams. *Boy in a Black Dress* (1989) presses a forefinger to his lips, and, looking at the spectator, seems to want to establish a kind of complicity: if the viewer doesn't mention what he sees, maybe no one else will notice. *Running Away* (1987), one of the most powerful of Kirby's early paintings, hints that the affrighted figures, fleeing from some unspecific catastrophe beyond the right edge of the canvas, are startled and indeed horrified by their costumes. That is, what they are in fact running away from is knowledge of their own sexuality. *The Tower* (1987) suggests that escape isn't possible. The cross-dressed figure is posed in front of one of Kirby's concentration camp watch-towers.

On occasion, the connotations of female attire become even more negative. One of the most beautiful of all Kirby's major canvases is *A Room Beyond* (1992). This shows a male figure – a youth rather than a fully grown man – clad in a long black dress with thin shoulder straps, and wearing a bridal wreath and a black veil. He is pulling open the door of a room which is filled with shadow, and seems to invite the viewer to enter. It is extremely difficult to give a specific meaning to this painting, and perhaps the critic shouldn't attempt too detailed a reading. It is, however, obvious that feelings about sex and death are here very intimately intertwined – gender confusion stands at the entrance to a threatening and melancholy nothingness.

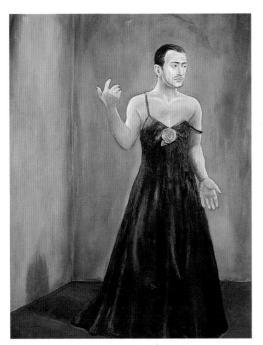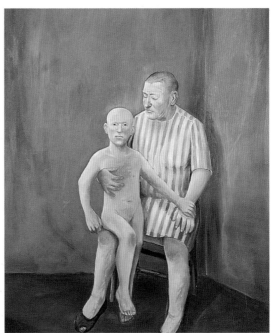

In Time of War (1986), oil on canvas, diptych, each panel 199 × 152 cm (78¼ × 59¾"), Private Collection

XXIII

The other subdivision of Kirby's 'gender' paintings contains images even more disturbing than those featuring men in women's dress. It offers variations on the theme of the 'male Madonna' – a man nurturing a child where one might expect to see a woman in that role. It is prefaced by one painting where the gender-roles are not yet altered, though the image is strange enough. *In Time of War* (1986) shows a rather masculine-looking woman wearing a dress with prison stripes; she has a prisoner's shaved head. A nude child – almost an adolescent – sits restlessly on her lap. The implication is that the relationship is a deeply uneasy one. Kirby says that the woman is in fact a portrait of his mother.

More tranquil – indeed almost a retort to this earlier work – is a painting from three years later. *All the Days of Our Lives* (1989) shows a man in a suit, standing, holding a nude baby. They are accompanied by a white, bull-terrier-like dog. An oblong of light on the wall suggests that they are looking out of an open window. Today, when the chores of parenthood are increasingly shared, there seems little which is disturbing about this image – that is, if one is careful to isolate it from its context.

Part of that context is supplied by *Parental Rites* (1989), where the image is similar, but slightly tougher. The adult male is now seated stiffly beside an open window, in a hieratic pose familiar from

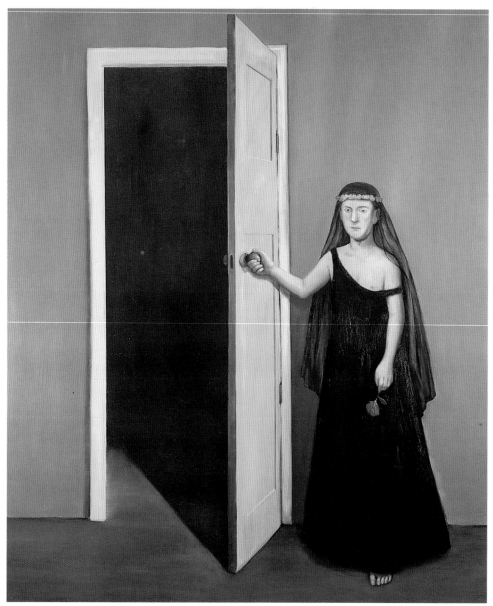

A Room Beyond (1992), oil on canvas, 214 × 183 cm (84 × 72″), Courtesy Angela Flowers Gallery

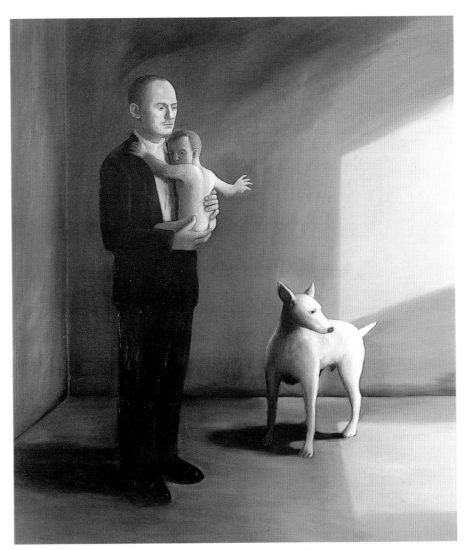

All the Days of Our Lives (1989), oil on canvas, 213.5 × 183 cm (84 × 72″),
Collection Darlene Lutz, New York

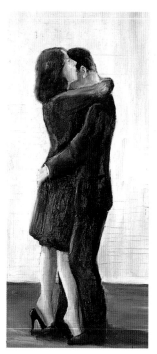

Other People's Lives (Souvenir of Pain) (1986), oil on board, 56.5 × 24.5 cm (22¼ × 9¾"), Private Collection

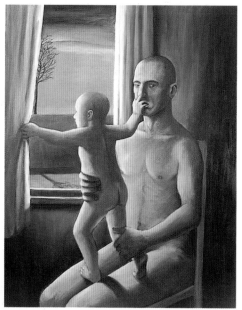

Parental Rites (1989), oil on canvas, 122 × 96.5 cm (48 × 38"), Heller Collection

Renaissance Madonnas. He is nude, and so is the child who stands on his lap, back turned to the spectator, looking out at the landscape. With one hand this child clutches a curtain, trying to draw it further back. The other hand he thrusts against the mouth of the man supporting him, as if to enforce silence. The artist uses the gesture to signal that there may be something forbidden about the relationship.

What that secret may be is exposed by a fourth variant on the same theme. In *Other People's Lives* (1986), the roles are largely reversed. The picture shows a seated man in a suit. His hands are folded limply in his lap, and he looks out of the canvas rather mistrustfully, disregarding a child whose own hand is barely touching one of his. This child, a miniature version of Kirby's men in dresses, is wearing a long black frock with thin shoulder straps. Here, too, there is a window, which gives a view of a watch-tower and what seems to be a prison yard.

It seems obvious that the paintings just described are saying more or less the same thing: where our sexual make-up is concerned, the child is formed by adults, largely by its parents. In one case, this parent is shown as affected by a view of sexuality which is already repressive (a dress made of prison stripes is visual shorthand for this). In another case the message is more complex: the father deliberately ignores his son's aberrant sexuality (once again symbolised by clothing), but both are imprisoned by their situation (the prison wall and watch-tower).

Most forthright of all are two paintings in which the male takes on actual female characteristics. In *Homeland* (1991), the

man stands, clothed but barefoot, in the midst of a wide landscape. His shirt is open to show that he has breasts, and the nude baby he holds is suckling at one of these. The motif is taken from late-medieval art, where the Virgin is often shown with her bodice open, suckling the Holy Infant.

Another closely related work is actually called *Madonna and Child (Precious Blood)* (1990), but here, perversely, the infant is missing. An androgyne is shown at a little less than half-length. One breast, full and heavy, with a swollen nipple, is entirely exposed. In his/her hand is a mask with which he half covers his face. The historical reference here is less to medieval Madonnas than to eighteenth-century Venetian portraits showing the subjects in carnival costume. Often they hold a mask in the same position. Gender-identity is here described as a masquerade.

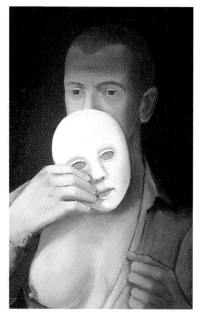

Madonna and Child (Precious Blood) (1990), oil on canvas, 59 × 42 × 22 cm (23¼ × 16½ × 8¾"), Private Collection, London

XXIV

Kirby's *oeuvre* contains one final major group. These are compositions in which the protagonist, entirely alone, or alone but for an animal companion, seems to be imprisoned. The settings are always bare and cell-like, though sometimes it is hard to be certain if a true prison is intended or not. This is the case, for instance, with Kirby's currently most publicly accessible work, the *Man with Rat* (1986) in the Ferens Art Gallery, Hull. Kirby liked the motif enough to make two later versions – one in which the man is clothed (*The Quartered Man*, 1988), and another in which he is nude

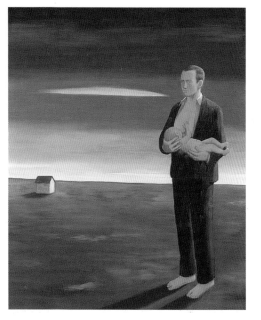

Homeland (1991), oil on canvas, 208 × 164 cm (82 × 64½"), Courtesy Angela Flowers Gallery

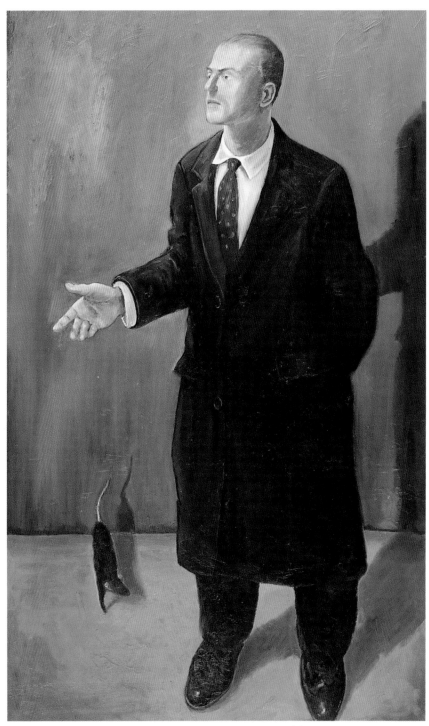

Man with Rat (1986), oil on canvas, 230.5 × 134 cm (90 × 52¾″), Ferens Art Gallery, Hull City Museums, Art Galleries and Archives

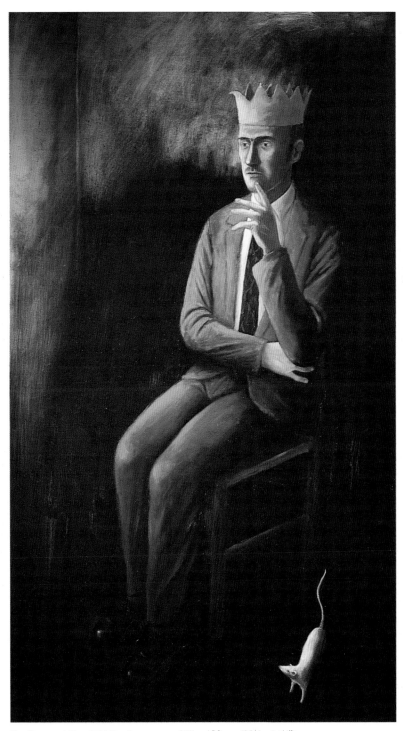

The Quartered Man (1988), oil on canvas, 229 × 130 cm (90¼ × 51¼"),
Collection Matthew and Huei Flowers

(*The Fate of Fools,* also 1988). In all three versions the man's pose is more or less the same, though the rat itself changes position.

The sense of imprisonment is more acute in another subgroup – *Vision of God* (1986), *Savage God* (1986) and *Crime of Passion* (1987). In each of these the standard Kirby-figure (always a vehicle for autobiographical commentary) is modulated yet again, and becomes a brutal tough. This is particularly the case in *Crime of Passion*, which shows a single nude figure, seated, in three-quarter back view. He is smoking, his eyes apparently fixed upon nothing. On the wall behind

him is a small crucifix. We are to infer, I think, that this is a condemned man in a cell, waiting out his last hours, perhaps having deliberately turned away from God.

In the other two paintings, the man, still nude, is accompanied by a black dog. In *Vision of God*, he looks upwards, as if struck by some sudden revelation – the dog looks upwards too, and seems to bay – but he looks in the opposite direction. *Savage God* also seems to represent some kind of visionary moment, but the man's gestures make it obvious that this has something directly to do with sex. He flings one arm across his chest, and covers his genitals

Crime of Passion (1987), oil on canvas, 124.5 × 118 cm (49 × 46½"),
Courtesy Angela Flowers Gallery

with the other hand – almost the gesture of a Venus pudica. His eyes, and those of his canine companion, are fixed on the naked light-bulb which hangs from the ceiling of the cell. This god, it is clear, forbids the expression of the sexual impulse.

Savage God, simply because of the attitude of the figure and its air of shocked horror, has a link with another and more recent work, which carries a biblical title, *Jeremiah Lamenting the Destruction of Jerusalem* (1992). In this the nude figure is no longer imprisoned, but perhaps wishes that he was. He pulls open a door, and at the same time hides behind it, covering his eyes with one hand. Through the doorway can be seen a high wall; beyond that is what looks like a factory, with a tall chimney belching smoke. The sky, where it is not covered with dark clouds, is a threatening red. This imagery, taken in conjunction with the actual title of the work, suggests that the subject is the Holocaust.

XXV

However, simply to declare patly that *Jeremiah Lamenting the Destruction of Jerusalem* is a painting about the Holocaust strikes me as a little risky. Any attempt to analyse Kirby's output uncovers a repertoire of recurring symbols: masks, rosaries, tattoos, prison stripes, watch-towers, men dancing together, men in women's dress. Yet do these symbols always carry the same fixed meanings? In the case of the simpler ones, meaning does indeed seem to be fairly constant. The appearance of the

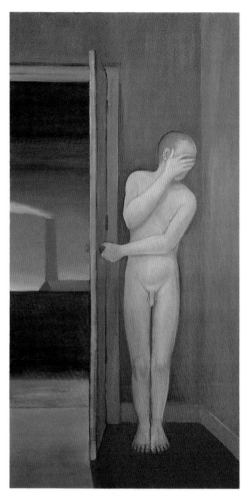

Jeremiah Lamenting the Destruction of Jerusalem (1992), oil on canvas, 122 × 61 cm (48 × 24"), Courtesy Angela Flowers Gallery

bluebird tattoo, for example, indicates that the figure upon whose arm it appears is to be regarded as a surrogate for the artist himself. In other cases the burden of meaning is complex. This is especially true of the male Madonnas and the men wearing women's clothes.

In fact, what we often meet is a collision between symbol and narrative. *Other People's Lives*, which brings together so many

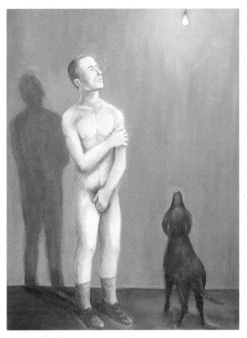

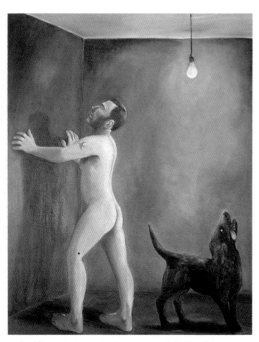

Savage God (1986), oil on board, 94 × 69 cm (37 × 27″),
Courtesy Rupert Blunt Fine Art

Vision of God (1986), oil on canvas, 198 × 101.5 cm
(78 × 40″), Royal College of Art Collection

Kirby archetypes, is an especially good example of this. How is the spectator to fit together the 'child' (in this case really a diminutive adult) wearing a dress, the man in a suit and the prison or concentration camp view revealed by the window? I think Kirby's own answer to this would be that we must link them in whatever way seems best to us, and that each spectator's version of what is shown will therefore be slightly different.

Artists like Kirby – those who bring very private feelings, and equally 'private' fragments of autobiography, into the public arena – suffer from a whole series of difficulties, ranging from the fear that they will, on the one hand, be completely misunderstood; and that they may, on the other, be understood only too clearly. An artist operating in the area Kirby is exploring

must often have the feeling of being brutally stripped of all concealments.

This no doubt is the reason why artists such as Bacon, Balthus and Freud have been so fierce – indeed sometimes almost frantic – in their determination to withhold biographical facts. The careers of all three of these artists are punctuated by controversies about untoward disclosures. A notorious example is the row that blew up concerning Sabine Rewald's catalogue essay for the Metropolitan Museum's Balthus retrospective of 1984. This so much offended the artist that he apparently lobbied a number of lenders, to get them to withdraw their work. Daniel Farson's gossipy memoir *The Gilded Gutter Life of Francis Bacon* (1993) indicates that Bacon, too, was equally reticent about personal details, and would give permission for

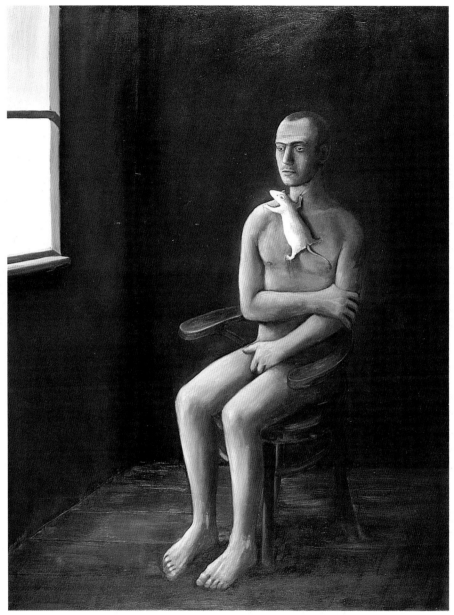

The Fate of Fools (1988), oil on canvas, 211 × 159.5 cm (83 × 62³/₄″), Private Collection, London

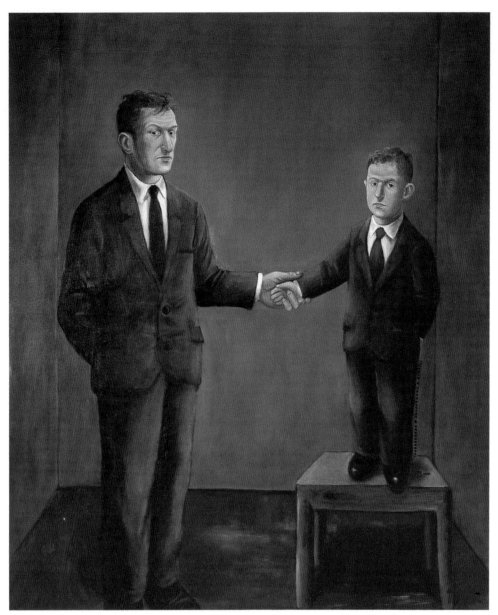

Man and Boy (1987), oil on canvas, 183 × 152 cm (72 × 60″), Collection Angela Flowers

books with a biographical element, only to withdraw it at the last moment. Sometimes his attitudes led to dissension amongst his admirers. Farson recalls an incident when Robert Melville, then the art critic of the *New Statesman*, referred to the 'suicide' of Bacon's lover, George Dyer, just as a major retrospective of the artist's work was opening at the Grand Palais in Paris:

> 'That was an awful thing to have done,' Francis accused him. 'What will people think? After all, they are only simple folk and won't understand.'
>
> Melville protested that he had not realised that Francis was against suicide, and Francis explained that he was thinking of George's parents. 'This sounded a bit odd to me,' wrote Melville, who added that John Russell [then critic at the *Sunday Times*] complained in a letter to the *New Statesman* that their art critic had done a despicable thing in calling it suicide when it wasn't. 'But of course, it *was.*'
>
> 'Of course it was,' Francis confirmed to me on the one occasion he referred to it. 'Are you foolish or something? Think of the timing. Of course it was deliberate.'[9]

Bacon later painted a major work, *Triptych – May–June 1973*, which is a very specific narrative of Dyer's death.

In fact, there often seems to be an unspoken convention, in the case of celebrated artists, that what is obvious from certain paintings, and indeed much gossiped about in private, should remain unmentioned in print. The convention is, however, increasingly fragile, since it rests on the assumption, equally unspoken, that art is the property of an élite.

XXVI

I am not suggesting that Kirby's work is a repository for paradoxically public secrets of this type, known from the paintings, but never to be put into written form, however sympathetic the commentator. I am suggesting that there is a certain vulnerability. This suspicion is confirmed by one of the few general comments Kirby is willing to offer about his painting. 'It's all about repression,' he says. We can deduce from the imagery itself that this repression is rooted in three things: dysfunctional family relationships during the artist's childhood; the experience of an especially rigid and repressive variety of Catholicism; and an array of sexual doubts, guilts and traumas.

Yet it would be complacent to assume that the meaning of the paintings is purely personal, if by this we mean entirely ego-centred. Art only moves us if it finds some echo in ourselves, so that we cease to look at it entirely from the outside but become, instead, incorporated into the emotional context to which the work belongs.

The power of Kirby's work springs from the fact that it so accurately mirrors doubts and fears which many people have in common. Basically, what he is trying to do is not just to find an image which provides an accurate mirror for some purely personal situation, but also to find one which unlocks an inhibition or a group of inhibitions for the spectator. The paintings are confrontational, but not in the generally accepted sense of the term. For example, they do not show anything violently horrifying or terrifying. The confrontation happens with the work of art as catalyst.

The viewer is shown some aspect of himself or herself which may seem threatening or disturbing. To make use of a perhaps exaggerated simile, the paintings are like the doors which lead to various chambers in Duke Bluebeard's castle.

Given the accepted conventions of contemporary art, one might expect Kirby's paintings to be at least loosely expressionist in manner, since expressionism is now the expected idiom for figurative art with a confrontational edge. Distortion and stridency of colour signal the violence of the artist's intentions. Instead of this, Kirby's paintings are smoothly painted, often slightly wooden – qualities which, as I have already suggested, may owe something to the art of Magritte. There is something cool and deliberate about them, mingled with something perhaps a trifle naïve – more primitive, in this purely technical sense, than the work of Hopper and Balthus, both of whom I have also proposed as influences.

I believe the easiest way of understanding this characteristic of Kirby's style is to look at a literary parallel – the use made of a mundane vocabulary, often combined with primitive ballad forms, by the young Wordsworth. Balthus once made a set of illustrations to Emily Brontë's *Wuthering Heights*. One can perhaps imagine Kirby illustrating these famously awkward lines from Wordsworth's *Peter Bell*:

> Is it a party in a parlour?
> Cramm'd just as they on earth were cramm'd –
> Some sipping punch, some sipping tea,
> But, as you by their faces see,
> All silent and all damned

It is always dangerous to put too much stress on comparisons between different art-forms – painting and literature, literature and music, music and architecture – but it does seem reasonable to suggest that there is a 'reforming' element in Kirby's work, just as there is in the Wordsworth of *Lyrical Ballads*: an effort to cut away stylistic dead wood, and get back to the essence of things. In both cases, this can make the work seem deliberately uningratiating, as perhaps in essence it is.

XXVII

To put so much stress on the function of imagery in painting begs all sorts of questions. Painting itself has, as I suggested earlier, been pushed away from the centre of artistic activity, to the point where many curators, especially in the United States, regard it as completely marginalized. Even if one refuses to grant the truth of this proposition there is not only stylistic plurality, but a wide plurality of intention within painting itself.

At the risk of repetition, it is worth recalling that painting can now be any of the following, separately or in combination:

(1) A way of activating and animating a surface, through colour or through the movements of the brush (or the movements of any other instrument which can be used to put paint on the surface in question).

(2) A way of reacting to perceived reality, by recreating it in two-dimensional form.

(3) A dialogue with established conventions of representation (this was one of the

major preoccupations of Pop Art).
(4) A dialogue with the photographic – of the sort which can be found in the work of certain Super-Realists, such as Chuck Close.
(5) A way of creating symbolic forms.
(6) A symbolic representation, with or without the addition of an element of personal calligraphy or handwriting.

What John Kirby does falls almost entirely into the sixth and last of these categories. He is an inventor of complex images or signs, and the various elements he uses have equivalents in the real world. This is not, however, to say that his recreation of them is genuinely realistic. It is only the confusion between realism and figuration (as opposed to abstraction) which might lead to him being described as a realist painter.

A question which immediately arises is whether this is, in existing circumstances, a possible way to proceed. It might be argued, for instance, that the proper vehicle for an image-maker of this type is collage: that what Kirby does has already been done better by such predecessors as John Heartfield and Max Ernst – the Ernst of *Une Semaine de Bonté.*

In my view the weakness of collage, however skilfully the technique is used, is its lack of visual unity and therefore its lack of inevitability. The spectator instinctively tries to pick out the disparate bits and pieces which have gone to create the finished design. Kirby's paintings have just sufficient of the element of what I have called handwriting to avoid this danger. Despite – or even because of – their slight primitivism, they offer a unified surface, all

of a piece. This encourages the viewer to read what is there as a totality. On the whole, however, it is not the kind of totality which would be familiar to a lover of Old Master painting – this, despite the numerous borrowings from and allusions to the pre-Moderns which are to be discovered in Kirby's work.

XXVIII

There is one kind of pre-Modern image-making to which Kirby's work does have a general resemblance, and this is the art of political and social caricature. To suggest this sounds pejorative: it is not intended to be so. In order to explain what I mean, it is necessary to say a brief word about the history of caricature itself, which is more complex than most people realise. Basically, the way in which we now use the word embraces two very different sorts of activity. One is making distorted or exaggerated likenesses of people, an activity which first became a fashion in seventeenth-century Italy, though sporadic instances are known in the art of the ancient world. It is this version of caricature which the *Oxford English Dictionary* concentrates upon almost exclusively in attempts to define the word:

1. In Art. Grotesque or ludicrous representation of persons or things by exaggeration of their most characteristic and striking features.
2. A portrait or other artistic representation, in which the characteristic features of the original are exaggerated with ludicrous effect.

In practice, however, the word 'caricature',

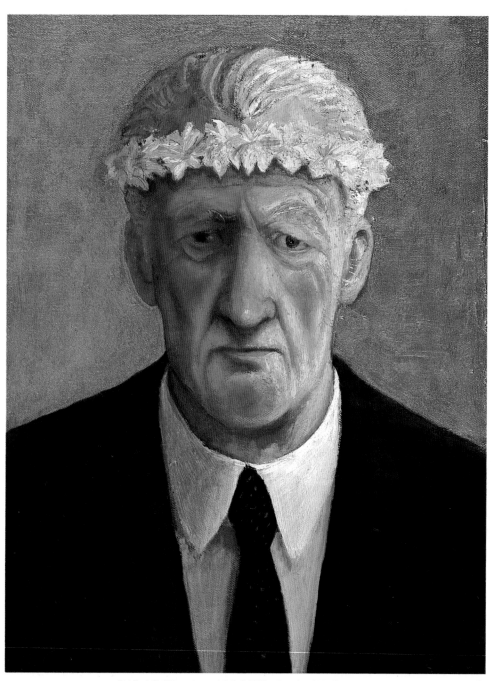

Old Fool (Self Portrait aged 84) (1993), oil and gold leaf on canvas, 40.5 × 30 cm (16 × 12″),
Courtesy Angela Flowers Gallery

despite its derivation from the Italian *cari-catura*, which means 'a likeness which has been deliberately exaggerated' – no more and no less – has taken on a much broader connotation. We use it for all kinds of allegorical and emblematic drawings which appear in the press, some of which may retain only the most tenuous connection with the idea of making a joke. Representations of this sort seem to have originated in the irreverent marginal decorations added to medieval manuscripts (often texts of the most serious sort) but reached their first maturity with the satirical prints of the late-fifteenth and early-sixteenth centuries. That is, they can be linked both to the introduction of printing and the rise of Protestantism.

The wars, famines and plagues of the years of acute religious conflict in Europe produced a rich harvest of such prints, amongst them Holbein's *Dance of Death* (1538), the prints and drawings representing *landsnechte* (mercenary soldiers) and their women by Urs Graf, and the engravings illustrating Netherlandish proverbs by Pieter Bruegel the Elder (1550s and 1560s).

Though similar themes were sometimes used in painting, they appeared much more frequently in graphic art, and there grew up an assumption that the graphic artist was at liberty to distort or change observed reality in ways forbidden to visual artists working in other media. The nineteenth century was an especially rich period for allegorical caricature of this sort. The great satirical draughtsmen of the time, chief among them Honoré Daumier, were able to allow themselves liberties with the established visual facts which were forbidden to the successful academic artists who showed their work in the official Salons, and forbidden even to the much-reviled Impressionists. It has long been recognised that the devices used by caricaturists of the period anticipate many of the visual liberties later taken by the Surrealists. Few surrealist transformations are as radical as the savage caricature published by Robert Gaillard in 1871, just after the overwhelming French defeat in the Franco-Prussian War, which shows a fat pig whose backside is metamorphosed into the features of the wretched Napoleon III.

What is less generally recognised is the fact that these allegorical or symbolic prints provide clear precedents for the work of a number of late-twentieth-century artists, among them John Kirby. The comparison between Kirby's paintings and the drawings of Daumier and others is illuminating. There is no stylistic resemblance, but they do have certain techniques – perhaps I should call them tactical devices – in common. Not all Daumier's symbols are original to himself. In *Peace, An Idyll*, published in *Le Charivari* in 1871, he shows a skeleton seated in a plain strewn with other skeletons, skulls and scattered bones, wearing a beribboned shepherd's hat and playing a pair of pipes. The skeleton is part of a symbolic vocabulary which can be traced back to Urs Graf and Holbein, and beyond them to medieval wall-paintings depicting the Dance of Death.

Kirby's paintings employ, as I have already suggested, a vocabulary of a similar sort. Part of this is inherited – his use of masks has a long history in European art – and part is invented. One instance of effective invented symbolism is his image of

men dressed as angels, wearing property wings. There is, however, a significant shift in his approach, and, linked to this, a shift in attitude. Nineteenth-century caricatures are, by their very nature, public statements, and their theme is public events. The artist speaks, not about his own inner nature but about the condition of the world, and he does so in an ephemeral form. These caricatures depended for their survival, not upon deliberate intention, but largely on the fact that they were disseminated in such large numbers. Their effect was always intended to be immediate.

Kirby, on the other hand, adopts a 'noble' or 'serious' (if now challenged) form of embodiment, paint on canvas, and what he expresses is essentially the workings of the inner self, even if some of his symbols, such as the prison watch-towers, depend for their full effect on the spectator's knowledge of twentieth-century history.

XXIX

It is one of the commonplaces of contemporary art criticism to complain about the pluralism of present-day art. This pluralism is often put forward as a reason for refusing to reach firm conclusions. In addition to this, all comparisons are held to be odious, even though the juxtaposition of one object, or group of objects, with another is one of the essential tools of academic art history.

Rather than judging an artist for his or her achievements, since fixed standards of achievement are so difficult to set, the critic increasingly relies on an elucidation of intention. The presumption is that the maker invariably achieves what he or she set out to do. Questions about the value of the intention itself are set to one side: anything the artist conceives of doing must, *ipso facto*, be worth the effort. When the situation is expressed in these rather bald terms, it becomes apparent that criticism is in trouble – never mind contemporary art.

Examining Kirby's work in the terms set out above is in any case extremely difficult, since few artists are so reluctant to speak about what they actually intended. The result Kirby looks for is what arises from the meeting between the work, once it is launched into the world, and the spectator.

One reason for this reluctance to explain, or so I suspect, is that each work, however simple and unitary the final image may seem, is the result of a fierce struggle. The repression which the artist calls the main subject of his art is also a key factor in his creative process. The pictures are born as a result of repressions and reticences barely overcome; their psychic force, when they are successful, echoes the inner explosion which produced them. Each is a hard-won truth, forcing its way out into the light of day.

The thing which, at first sight, militates against this explanation is the fact that the painting itself is not mimetic – neither the forms nor the actual brushstrokes which create those forms are suggestive of inner turmoil. Even when Kirby shows a man howling inconsolably, as he does in *The Abandoned* (1991), the forms remain rigid – a wall of glass seems to separate the artist from his subject. This is true of all his paintings, even those in which the figures

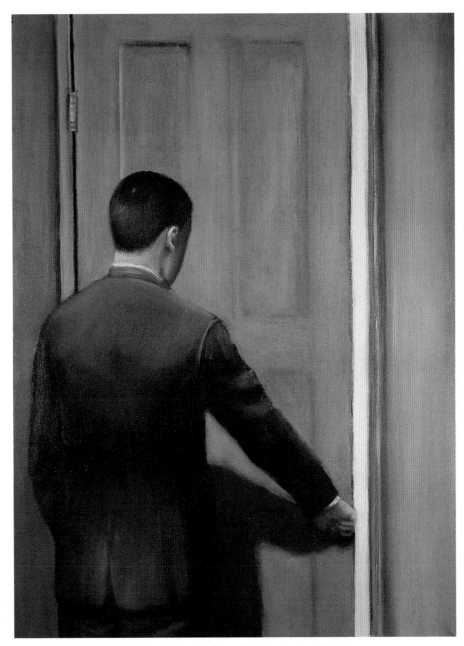

The Door (1989), oil on canvas, 68 × 53.5 cm (26¾ × 21″), Edgar Astaire Collection

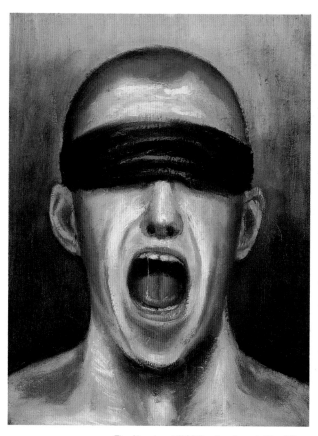

The Abandoned (1991), oil on board, 41 × 30 cm
(16 × 12″), Courtesy Angela Flowers Gallery

are at their most abject, such as the humiliated nude figure in *Something a Bit like Praying* (1986). Bill Hopkins, Kirby's great admirer, speaks of the 'icy coldness' of his work.[10] What one has to consider is the idea that this coldness may in fact be a defence – that the artist may often feel more threatened by the content of the work than we do ourselves, when looking at it.

XXX

The conclusion I draw from the conjunction of style and subject in Kirby's work – subjects often at the extremes of emotion or experience, but an actual method of expression which remains slightly stiff and buttoned up – is that each work is in one form or another an act of purgation, but an act which always stops short of the completeness desired by the artist. If he achieved that (one guesses, perhaps impertinently), he might well stop painting altogether.

Kirby is generically 'modern' in one very important sense: he lives and works in an age when the artist's main subject has become the workings of the self. This focus on the self is not something entirely new in European art. We can see its beginnings in the Romantic epoch, for example in some of the most famous paintings of Delacroix, such as *The Death of Sardanapalus*. Even there, however, the artist's approach remains oblique. He is giving expression to his own inner turmoil, but he is doing so by illustrating a literary text, Byron's tragedy *Sardanapalus*, published in 1821, seven years before the picture was painted.[11] The contemporary artist, by contrast, tends to invent his or her own myths, which have a direct relationship to actual life experiences. This is obviously true in the case of Kirby.

One should not, despite this well-established fact, conclude that the artist necessarily rushes towards self-exposure. It is one of the fascinations of Kirby's paintings that the viewer's relationship with them often resembles a game of hide-and-seek. It may sound from this as if Kirby's self-rev-

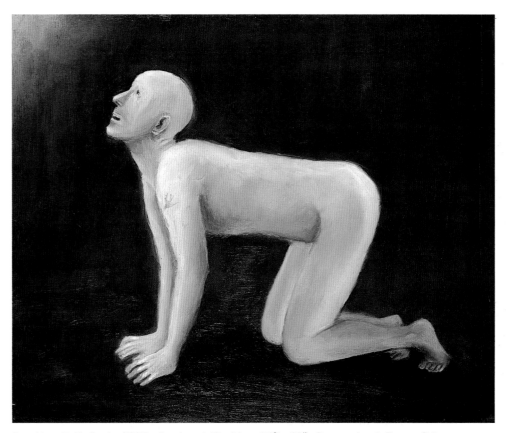

Something a bit like Praying (1986), oil on board, 48 × 56 cm (18¾ × 22″), Courtesy Angela Flowers Gallery

elations are irritatingly coy, proffering information and then withdrawing it. In fact, what is shown is not at this level of self-consciousness. The artist seems to be trying out different roles, exploring alternative solutions to old problems, new ways of healing psychic wounds, while allowing the viewer to witness the process.

There is, of course, an element of exhibitionism in this, of a kind which now permeates contemporary art taken as a whole. Kirby is a man of his time, and cannot escape entirely from the cultural matrix which firmly fixes him in place, together with all other practitioners of the visual arts, despite the apparent diversity of their products.

What is moving is the melancholy note which sounds through so much of Kirby's work. The paintings, in addition to being tentative attempts to find modes of exorcism and means of healing, are laments for loss. I have noted Kirby's frequent preoccupation with images of children. Yet these are seldom children in the present; they are usually ghosts from the past, *doppelgängers* for the adults they accompany. They are what was, and also what might have been. They are maimed, on occasion quite literally, by the demands of the adult world.

Having already noted the danger of making direct comparisons between works of literature and works of art, I nevertheless cannot resist suggesting just such a comparison here. The personal world of the imagination which (to me at least) Kirby's most resembles is that of Samuel Beckett. This is more obvious from some of the paintings than from others. The desolation of *Something a Bit like Praying* immediately prompts the idea. Other paintings, perhaps better ones, seem too peopled, too full of movement, for them to have much resemblance to Beckett's stripped-down universe.

Yet there are important points where these two creative sensibilities seem to touch. Kirby's bare landscapes, and barer rooms, are very much like the settings which Beckett specified for his plays. *Waiting for Godot* offers a series of scenes which might almost be suggestions for paintings by Kirby. Even the language Beckett uses in this, his most celebrated play, has a hidden point of contact with Kirby's tastes and feelings. It is the language of old-time music-hall routines. Bill Hopkins, whose father was a star of the music-hall, notes Kirby's unexpected relish for this kind of material. Once one knows this, it accounts for the unexpected popular edge to the work – some paintings might be inn-signs redesigned by Dr Kinsey. The more one looks, the more clearly one perceives that even the most apparently heartfelt statements of distress are undercut by the kind of tough irony one finds in music-hall comedy. Beckett's two protagonists, in *Waiting for Godot*, are essentially survivors. In fact, they exasperate the audience by their determination to survive in the face of total discouragement. Kirby's paintings also strike me as declarations of a determination to survive in the face of adverse circumstances. What Bill Hopkins describes as their 'coldness' I would describe as their unswerving determination. They are paintings where the artist is convinced he has something to say, and he is not too much concerned whether the audience likes it or not.

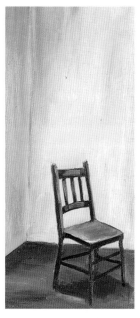

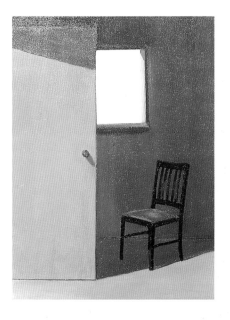

Chair (1988), oil on board, 56.5 × 24.5 cm (22 × 10″), Private Collection

The Living Room (1991), oil on canvas, 65 × 49.5 cm (25½ × 19½″), Collection Peter and Maria Kellner

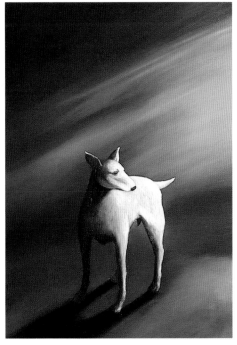

Landscape with Tree (1993), oil on board, 81 × 61 cm (32 × 24″), Courtesy Angela Flowers Gallery

A God Unknown (1989), oil on canvas, 160 × 114 cm (63 × 45″), Courtesy Houldsworth Fine Art

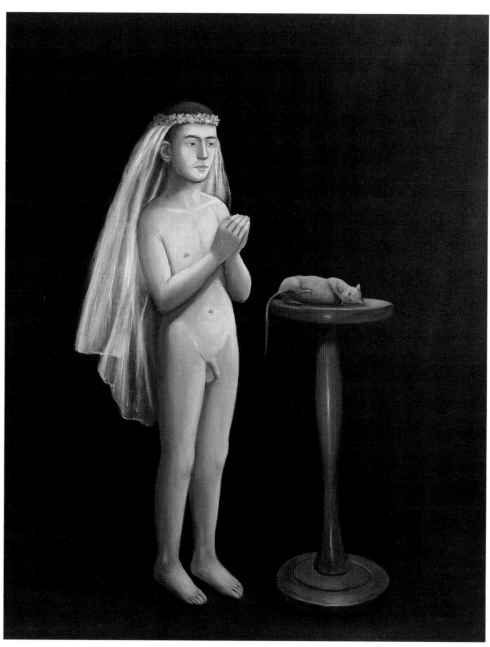

Prayers for a Dead Rat (1990), oil on canvas, 152.5 × 122 cm (60 × 48″), Courtesy Angela Flowers Gallery

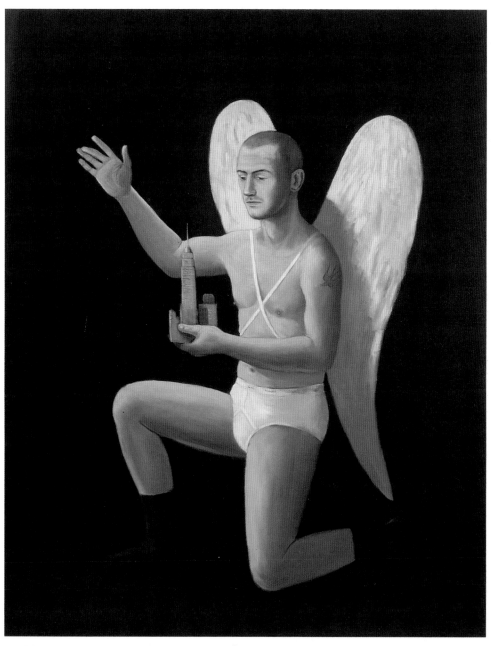

The Gift (1990), oil on canvas, 152.5 × 122 cm (60 × 48″), Courtesy Angela Flowers Gallery

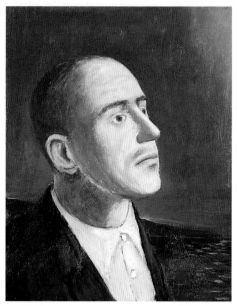

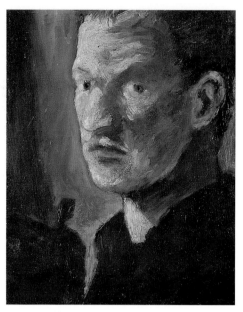

A Manxman looks at the Moon (1986), oil on canvas, 51 × 40.5 cm (20 × 16″), Private Collection

Self Portrait (1984), oil on board, 30 × 24 cm (12 × 9½″), Collection Angela Flowers

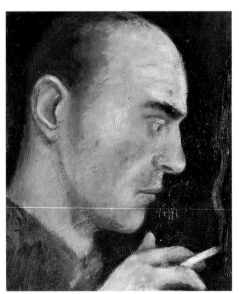

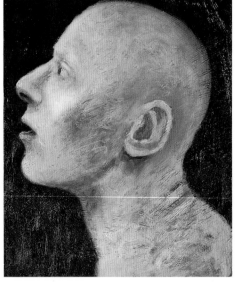

Untitled (1986), oil on board, 38.5 × 32 cm (15 × 12½″), Private Collection

Untitled (1986), oil on board, 38 × 32 cm (15 × 12½″), Private Collection

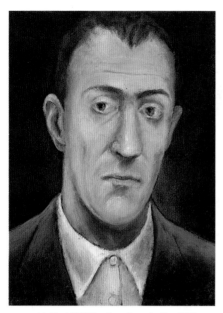

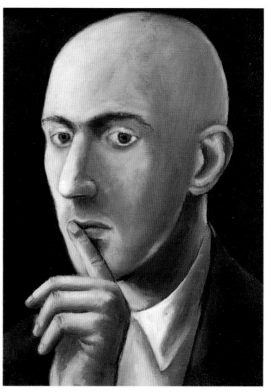

Untitled (1987), oil on board, 41 × 29.5 cm
(16¼ × 11½"), Private Collection

Head (1987), oil on board, 53.5 × 40.5 cm (21 × 16"),
Collection Frank and Susan Delaney

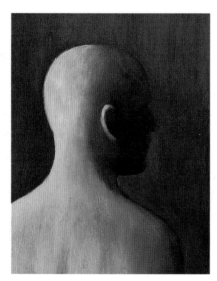

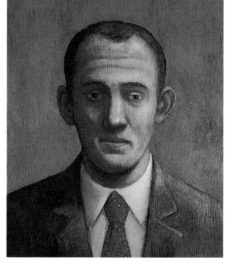

Untitled (1988), oil on board, 38 × 29 cm
(15 × 11½"), Marion and Guy Naggar Collection

A Single Man (1994), oil on board, 35.5 × 30.5 cm
(14 × 12"), Collection Karen Demuth

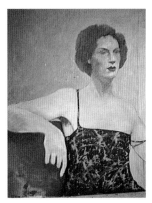 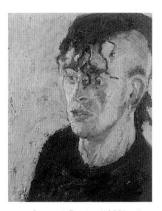 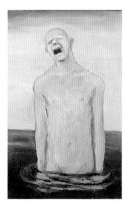

Woman (1982), acrylic on canvas, 91.5 × 86.5 cm (36 × 34″), Collection Stephen Jenn

Boy with Earring (1983), oil on canvas, 35 × 27.5 cm (14 × 11″), Collection of Mr and Mrs Carmichael

Untitled (1985), oil on board, 45 × 29 cm (18 × 11½″), Private Collection

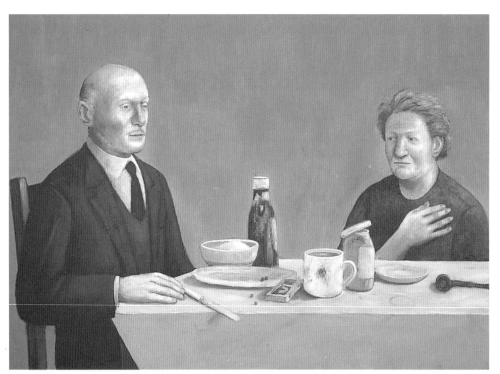

The Last Supper (1984-91), oil on canvas, 89 × 123 cm (35 × 48½″), Collection the Artist

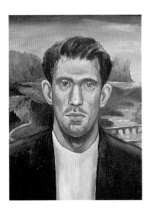

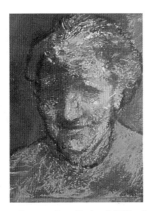

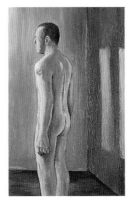

Man with a Spot (1986), oil on board, 75 × 50 cm (29½ × 19¾″), Private Collection, USA

Portrait of my Mother (1978), oil paint and oil pastels on paper, 23 × 15 cm (9 × 6″), Collection the Artist

Untitled (1986), oil on board, 74.5 × 49 cm (29¼ × 19¼″), Private Collection

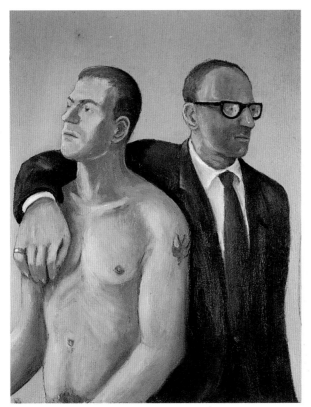

The Hollow Men (1986), oil on board, 62 × 52 cm (24½ × 20½″), Courtesy Angela Flowers Gallery

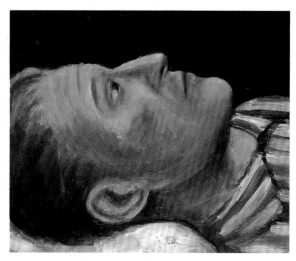

Untitled (1986), oil on board, 41 × 35 cm (16¼ × 14″),
Collection Rachel Heller

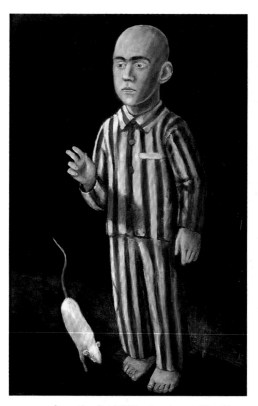

Boy with a Rat (1987), oil on board, 93 × 60 cm
(36½ × 23½″), Heller Collection

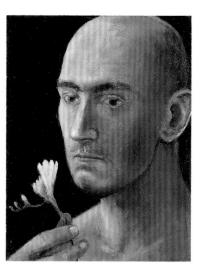

Man with a Yellow Flower (1987), oil on
board, 32 × 25 cm (12½ × 10″),
Private Collection

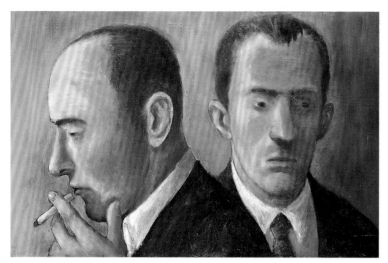

Business Men (1987), oil on board, 38 × 58.5 cm (15 × 23″), Private Collection, London

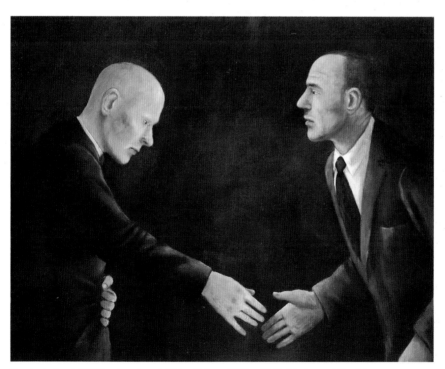

Keeping in Touch (1987), oil on board, 101 × 126 cm (39¾ × 49½″), Marion and Guy Naggar
Collection

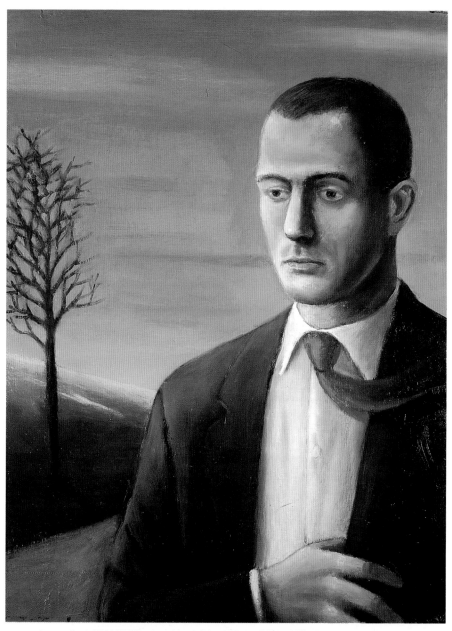

Strange Land (1988/1989), oil on board, 74 × 58.5 cm (29¼ × 23″), Courtesy Angela Flowers Gallery

Strangers in the Park (1988), oil on board,
127.5 × 96 cm (50 × 38″), Private Collection

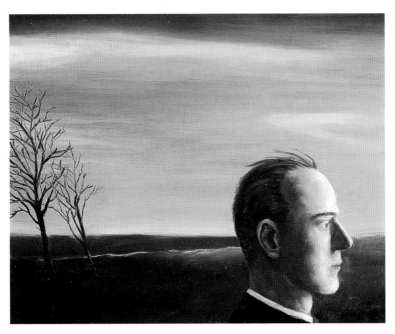

The Stranger (1988), oil on board, 71 × 85 cm (28 × 33½″), Private Collection

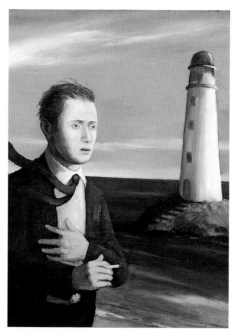

Untitled (1988), oil on board, 74 × 59 cm (29¼ ×
23¼"), Collection John and Ingrid Thomson

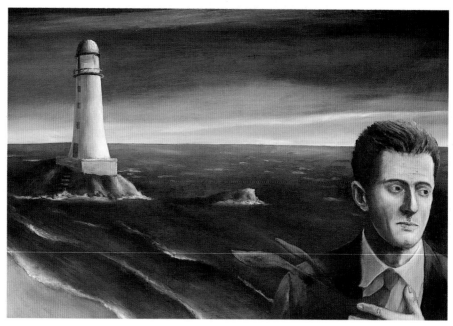

My Dark Rosaleen (1988), oil on board, 64 × 94 cm (25¼ × 37"), Collection Frank and Susan Delaney
(commissioned by Frank Delaney for the cover of his novella, *My Dark Rosaleen)*

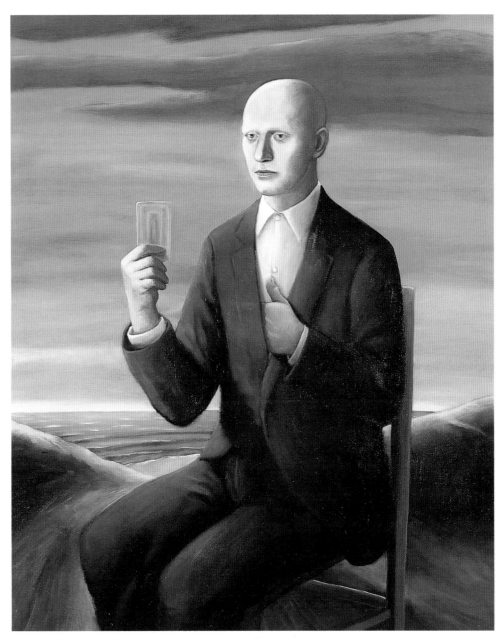

Prospect of the Sea (1989), oil on canvas, 147 × 120 cm (57¾ × 47¼"), Courtesy Angela Flowers Gallery

Woman with a Dog (1989), oil on canvas, 190 × 154 cm (74¾ × 60½"), Marion and Guy Naggar Collection

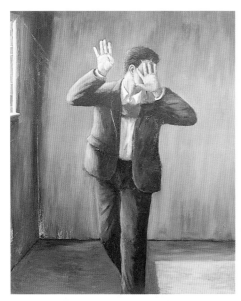

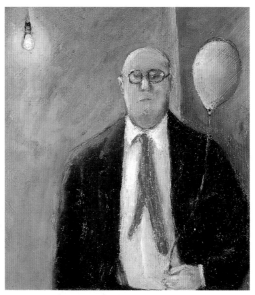

Not I (1989), oil on canvas, 183 × 152.5 cm (72 × 60″), Marion and Guy Naggar Collection

Man with a Balloon (1988), oil on board, 23 × 20 cm (9 × 7¾″), Collection Patrick Flowers

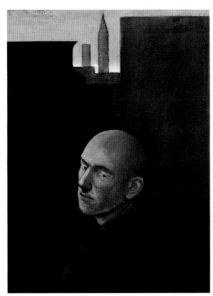

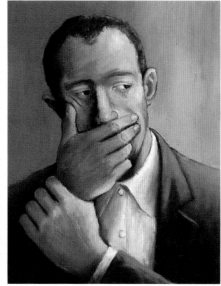

The City (1990), oil on canvas, 76 × 56 cm (30 × 22″), Collection Nelson Woo

Man of Iasa (1989), oil on canvas, 46 × 36 cm (18 × 14¼″), Courtesy Angela Flowers Gallery

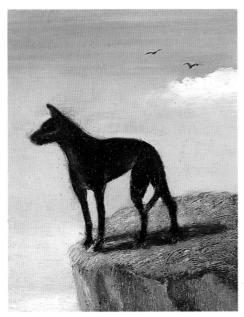

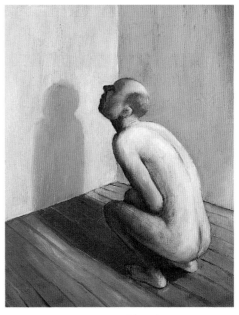

Black Dog with Crows (1992), oil on board, 20 × 16 cm
(7¾ × 6¼″), Private Collection, USA

Untitled (1987), oil on board, 39.5 × 31.5 cm
(15½ × 12½″), Heller Collection

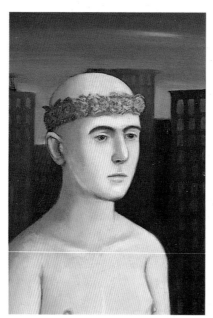

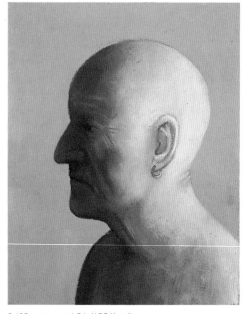

Untitled (1991), oil on canvas, 57 × 44.5 cm
(22½ × 17½″), Private Collection, Canada

Self Portrait aged 86 (1991), oil on canvas,
35.5 × 28 cm (14 × 11″), Private Collection

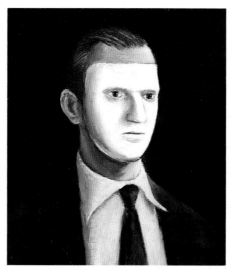

The Outsider (1988), oil on board, 33 × 28 cm
(13 × 11″), Private Collection

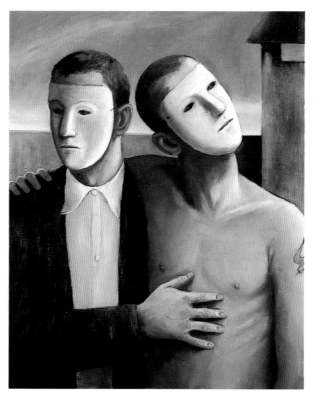

Masked Men (1989), oil on board, 87 × 72 cm (34¼ × 28¼″),
Private Collection

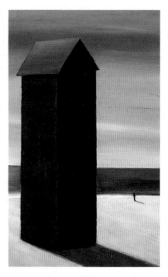

Signs of Life (1990), oil on canvas, 76 × 61 cm
(30 × 24″), Collection Mr and Mrs T. B. Morton

The Beach (1991), oil on board,
67 × 48 cm (26¼ × 19″),
Collection Mr and Mrs T. B. Morton

The Open Door (1991), oil on canvas, 149 × 111 cm (58¾ × 43¾),
Courtesy Angela Flowers Gallery

Down to the Sea (1993), oil on canvas, 168 × 109.5 cm (66¼ × 43″), Courtesy Angela Flowers Gallery

West of Here (1993), oil on board, 81.5 × 61 cm (32 × 24″),
Courtesy Angela Flowers Gallery

The Far and Distant Place (1993), oil on
board, 25.5 × 19.5 cm (10 × 8¾″),
Private Collection

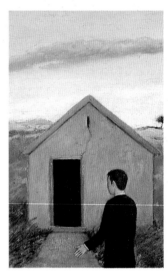

I Thought I Saw Jesus (1993), oil on
board, 32.5 × 20.5 cm (12¾ × 8″),
Private Collection

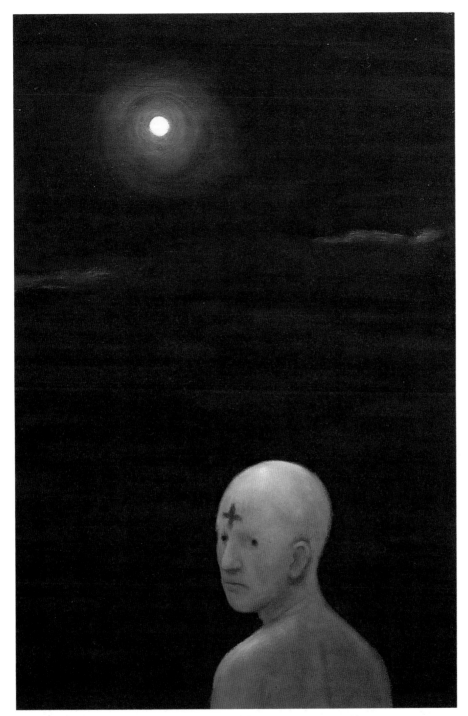

The Moon (1993), oil on canvas, 92 × 69 cm (36¼ × 27¼″), Collection Yen Chjuin Hong

In My Bed (1993), oil on board, 61.5 × 91.5 cm (24 × 36″), Courtesy Angela Flowers Gallery

Ghost (1994), oil on board, 87 × 101 cm (34¼ × 36¾″), Courtesy Angela Flowers Gallery

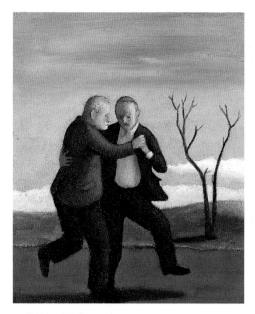

Old Men (1993), oil on canvas, 30 × 25 cm (12 × 10″),
Courtesy Angela Flowers Gallery

Landscape with Chimney (1993), oil on board, 81 × 61 cm
(32 × 24″), Courtesy Angela Flowers Gallery

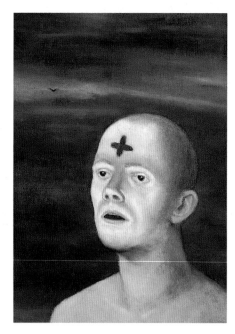

The Dark (1993), oil on canvas, 39 × 30 cm
(16 × 12″), Private Collection, USA

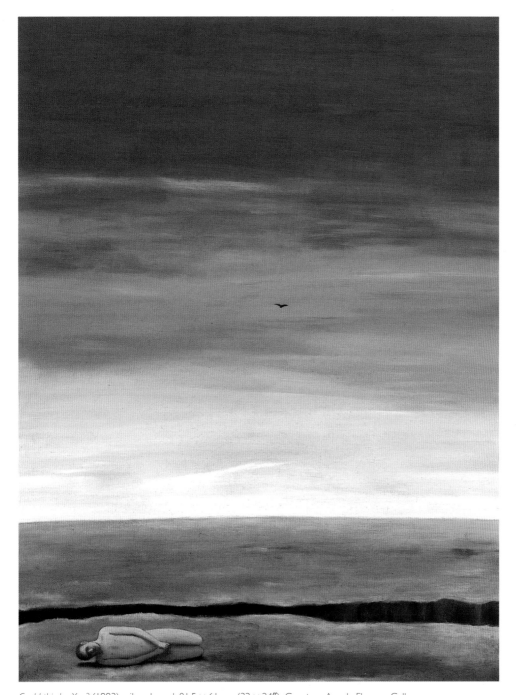

Could this be You? (1993), oil on board, 81.5 × 61 cm (32 × 24″), Courtesy Angela Flowers Gallery

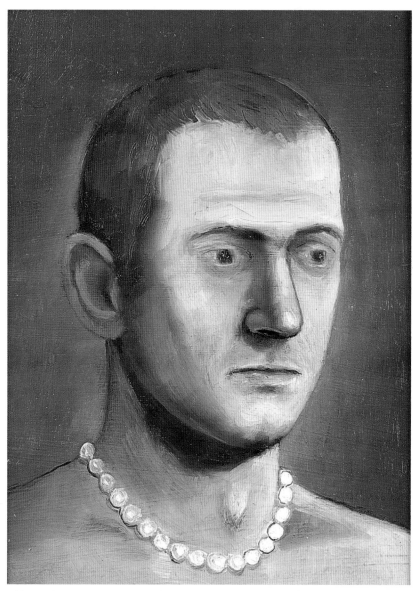

Man in a Pearl Necklace (1991), oil on board, 29.5 × 24 cm (11½ × 9½"), Private Collection, USA

BIOGRAPHY OF THE ARTIST

1949	Born in Liverpool
1965–67	Shipping clerk
1967–69	Salesman in Catholic bookshop
1969–71	Boys Town of Calcutta, assistant to the Director
1971–82	Variety of jobs, mainly in social work
1982–85	St Martin's School of Art, London
1986–88	The Royal College of Art, London

Solo Exhibitions

1987	'Artist of the Day', Angela Flowers Gallery, London
1988	'Other People's Lives', Angela Flowers (Ireland) Inc
1989	'Still Lives', Flowers East, London
1991	'New York and Related Works', Flowers East, London
	'Homeland', Lannon Cole Gallery, Chicago
1992	'Homeland', Flowers East, London
1993	'The Sign of the Cross', Angela Flowers Gallery, London
1994	'The Company of Strangers', Flowers East at London Fields

Group Exhibitions

1984	John Player Portrait Award Exhibition, National Portrait Gallery, London
1985	'85 Degree Show', Serpentine Gallery, London
1986	'Canvas Two', John Hansard Gallery, Southampton and Milton Keynes
	'One Year On', International Contemporary Art Fair, Olympia, London
	John Player Portrait Exhibition, National Portrait Gallery, London
	'New Acquaintance', Fabian Carlsson Gallery, London
1987	'Three Artists Show', Underground Gallery, Bath
	'The Self Portrait: A Modern View', Artsite Gallery, Bath and touring
	'Flowers', Anne Berthoud Gallery, London
1988	'Contemporary Portraits', Flowers East, London
	'The London Influence', Slaughterhouse Gallery, London
	'Figure II Naked: A Private Mythology', Aberystwyth Art Centre; Victoria Art Gallery, Bath; Mide-Oennine Arts Association, Burnley, Lancs; The Arts Centre, Wrexham

1989 Sex and Sexuality Festival, Diorama Gallery, London
 'Big Paintings', Flowers East, London
 'The Thatcher Years: an Artistic Retrospective', Flowers East, London
 'Daley, Hicks, Jeffries, Jones, Kirby, Lewis', Flowers East, London
 'Angela Flowers Gallery 1970–1990', Barbican Concourse Gallery, London
1990 'Flowers at Moos', Gallery Moos, New York
 'The Soul', Diorama Gallery, London
 'Madonnas', Diorama Gallery, London
 'Small is Beautiful Part VIII: The Figure', Flowers East, London
1991 'Angela Flowers Gallery 1991', Flowers East, London
 Inaugural Exhibition, Lannon Cole Gallery, Chicago
 'The Cabinet Show', Gillian Jason Gallery, London
1992 'Artist's Choice', Flowers East, London
 'Fin quando sara pittura', il Polittico, Rome
 'Small is Beautiful Part X: Animals', Flowers East at London Fields, London
1993 'Portrait of the Artist's Mother done from Memory', Flowers East, London
 'New Figurative Painting', Salander-O'Reilly Galleries/Fred Hoffman,
 Beverley Hills, California, USA
 'Small is Beautiful Part XI: Homages', Flowers East, London
 'New Work', Flowers East at London Fields, London
1994 'Inner Visions', Flowers East, London
 'Back to Basics: A Major Retrospective', Flowers East, London

Public Collections
Contemporary Art Society
Ferens Art Gallery, Hull
Irish Contemporary Art Society
John Hansard Gallery, University of Southampton
Royal College of Art Collection
TI Group
University College of Wales, Aberystwyth

BIBLIOGRAPHY

Sewell, Brian, 'Why Bright Boys Never Win', *Evening Standard*, 15 August 1985

Time Out, 8–14 August 1985

Auty, Giles, 'Student Promise', *The Spectator*, 11 July 1987

Kelly, Sean, and Lucie-Smith, Edward, *The Self Portrait* (Sarema Press, 1987)

Time Out, 8–15 June 1988

Beaumont, Mary Rose, 'Contemporary Portraits', *Arts Review*, 7 October 1988

Fuller, Peter, *Midweek*, October 1988

Hourahane, Shelagh, *Arts Review*, 16 December 1988

Howell, Sarah, 'Hung for Less', *The World of Interiors*, June 1988

Bennett, Oliver, *New Art Examiner,* November 1989

Hall, Charles, *The Guardian*, 7 November 1989

Hall, Charles, 'Pick of the Week', *The Guardian*, 27 November 1989

Oulton, Isabella, catalogue introduction, *Still Lives*, 1989

The Guardian, 30 November 1989

What's On, 6 December 1989

Evening Standard, 8 December 1989

Beaumont, Mary Rose, *Arts Review*, 15 December 1989

Feaver, William, *The Observer*, 17 December 1989

Lubbock, Tom, *The Sunday Correspondent*, 17 December 1989

Currah, Mark, *City Limits*, 20–27 July 1989

Fuller, Peter, 'The Paradoxes of the Thatcher Years', *The Sunday Telegraph*, 30 July 1989

Beaumont, Mary Rose, 'The Thatcher Years', *Arts Review*, 11 August 1989

Lucie-Smith, Edward, 'John Kirby: Revelation and Ambiguity', *The Green Book Volume III*, 1989 (published by The Green Book Ltd)

Cook, William, *What's On and Where to Go*, 17 January 1990

Kent, Sarah, 'My Pleading Heart', January 1990

Hubbard, Sue, 'Diary of an Unknown Woman', *Time Out*, 16–23 May 1990

Packer, William, 'A Seasonal Pot Pourri', *Financial Times*, 17 December 1991

The Independent, 22 January 1991

Macdonald, Robert, *Time Out*, 30 January 1991

Auty, Giles, *The Spectator*, 11 July 1992

Lucie-Smith, Edward, 'The Art of Darkness', *The Telegraph Magazine*, November/

December 1992
Apuelo, Vito, 'Pittura Culta al Polittico', *Messagero di Roma*, 27 December 1992
Rossi, Sergio, 'Tia Sugna e ironia', *Paese Sera*, 2 January 1993
Beaumont, Mary Rose, *Arts Review*, 25 January 1993
Kent, Sarah, *Time Out*, 15 September 1993

Notes

1. Roger de Piles, *Abrégé de la vie des peintres* (1699).
2. Denis Diderot, 'Salon de 1763, *Oeuvres complètes*, Vol X (Paris, 1876).
3. Ibid, 'Salon de 1761'.
4. E.J. Délecluze, *Louis David* (Paris, 1855).
5. Tim Hilton, *Picasso* (London, 1975), p.246.
6. René Magritte, 'Esquisse autobiographique', *Ecrits complets* (Paris, 1979).
7. Suzi Gablik, *Magritte* (London, 1970), p.11.
8. Tape-recorded interview with the author, 13 January 1994.
9. Daniel Farson, *The Gilded Gutter Life of Francis Bacon* (London, 1993), p.184.
10. Tape-recorded interview, 13 January 1994.
11. *Eugène Delacroix 1798–1863*, catalogue of the Exposition du Centenaire, (Paris, 1963), p.42.